Sights & Insights

The Art & Heart of John E. Heiss

Captions and images by John E. Heiss.
Book Creation by Thomas E. Uharriet

© 2010 by Peace Publishers, a subsidiary of Manna Corp.
All rights reserved including the right of reproduction in whole or in part in any form.

To use any of these copyrighted images—or (for a limited time only) to have new original images specially designed for you for the creation of stained glass windows, or if you would like mugs, posters, or acrylic paintings, of the same designs, please contact the artist directly at johneheiss@gmail.com. For priority processing, please type in the subject line, "SIGHTS & INSIGHTS."

ISBN-13: 978-1489521446

Introduction

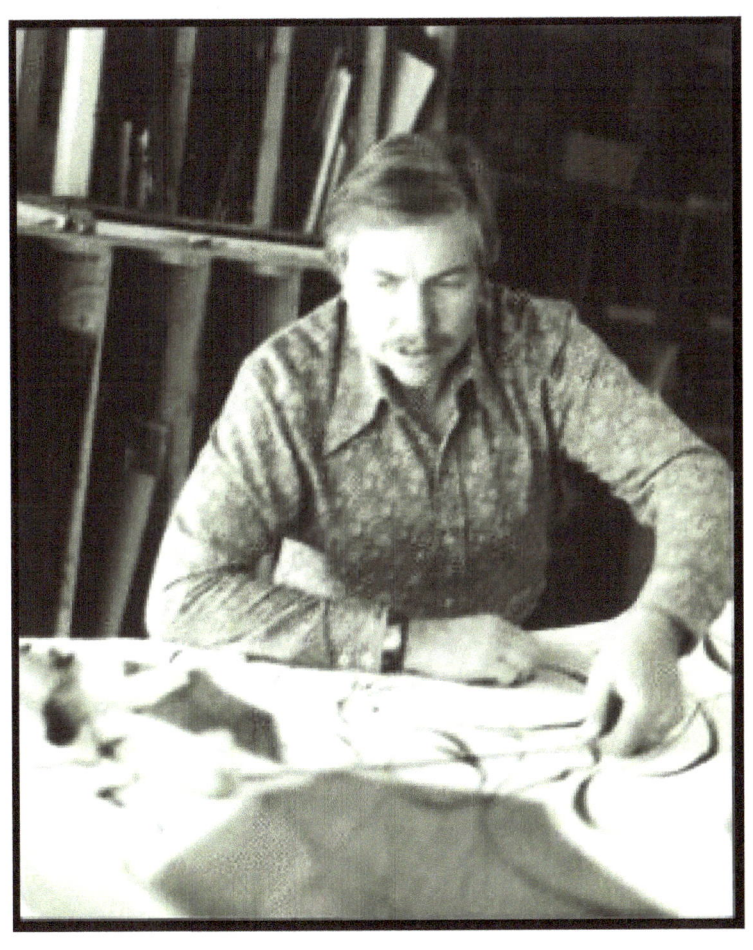

After obtaining his Bachelor of Fine Arts degree from the University of California at Berkeley, John E. Heiss studied painting in West Germany with Herman Kimner, and did graduate work at the University of Utah, studying oil painting and other media with Douglas Snow. Heiss also studied commercial design at the Art Center School in Los Angeles.

In the 1970s, Heiss founded The Stained Glass Place, a studio in Claremont, California, where he made over 200 leaded windows and room dividers, and where he taught the stained glass art. Heiss also taught stained glass classes at California Polytechnical University in Pomona, and at Mount San Antonio College in Montclair, California. Furthering his own design development in contemporary stained glass, Heiss studied under Ludwig Schaffrath, a leaded glass designer from Germany.

John E. Heiss' current art studio is near Seattle, Washington. His distinctive style of integrating human figures into each stained glass design sets him apart as a genuinely unique and intriguing talent to this day. His design objective, he says, is "to create art which delights the eye, feeds the spirit, and enlivens the inquisitive mind to esoteric understanding." His ambiguous images call for watchfulness and contemplation. Their viewing is not to be rushed. Some viewers report discovering new figures years after the windows are installed.

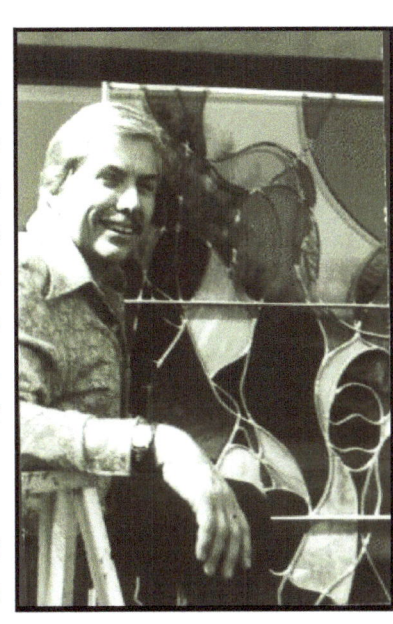

The art that follows are Heiss' designs. Although the fullest splendor is only realized by viewing them in glass, as shown

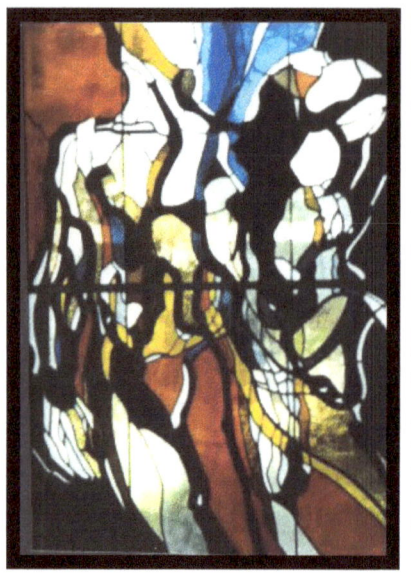

in this Introduction, this book reveals this break-through in leaded glass design. It is revolutionary when compared with traditional stained glass.

As you view the John E. Heiss design sketches, and consider this remarkable evolution in the stained glass art form, you too will understand what sets Heiss apart as a profound leaded glass designer of our time. As you ponder the layers of symbolic meanings woven into each design, you too will want Heiss designed windows or paintings in your own home, business, and public buildings. For a very limited time only, that can still be arranged.

Sights & Insights

The inner spirit struggles to ascend to seek and bond with Deity. The natural man resists.

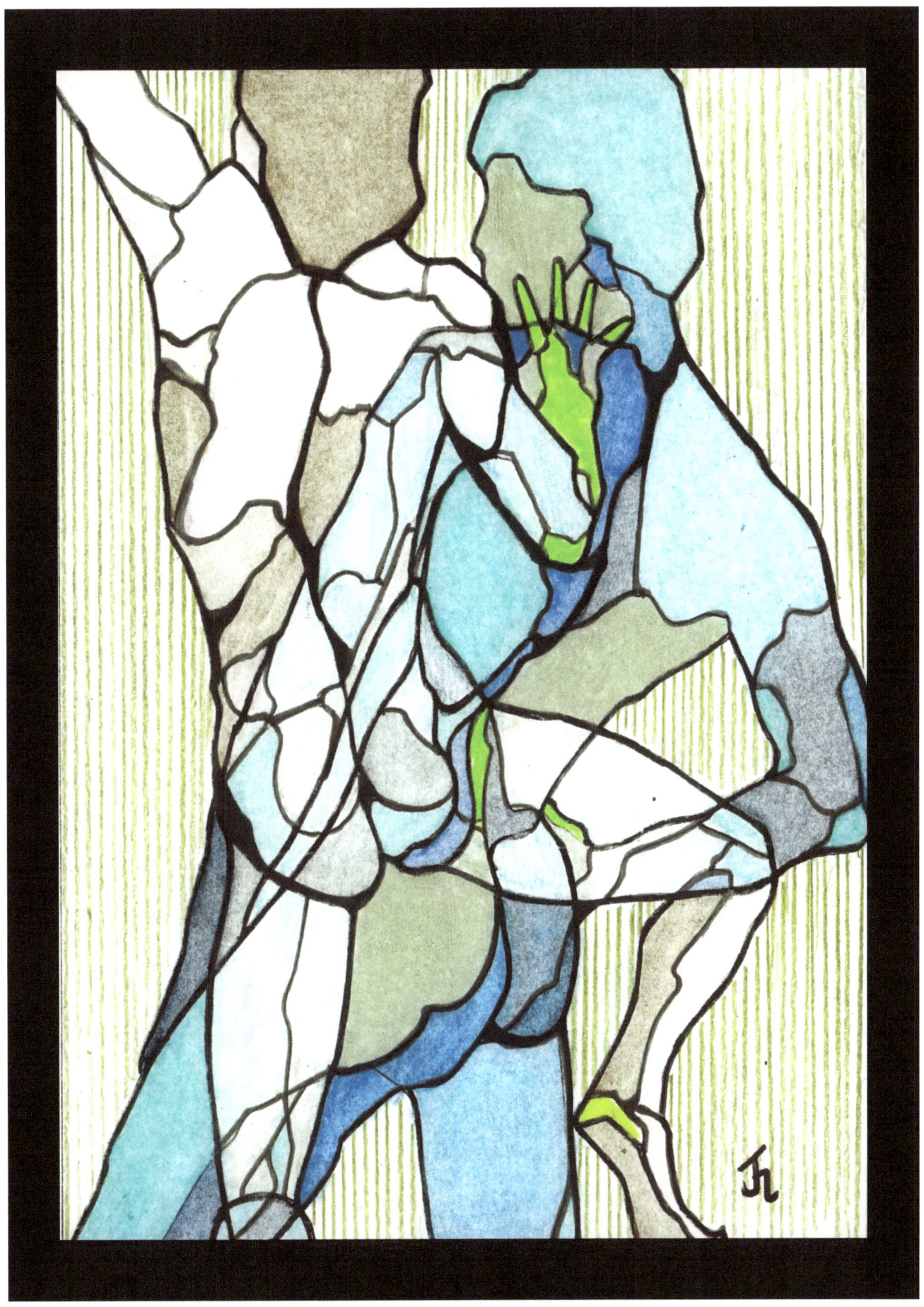

We seek perfection in our physical balance. Why then do we oft allow spiritual balance to go unchecked?

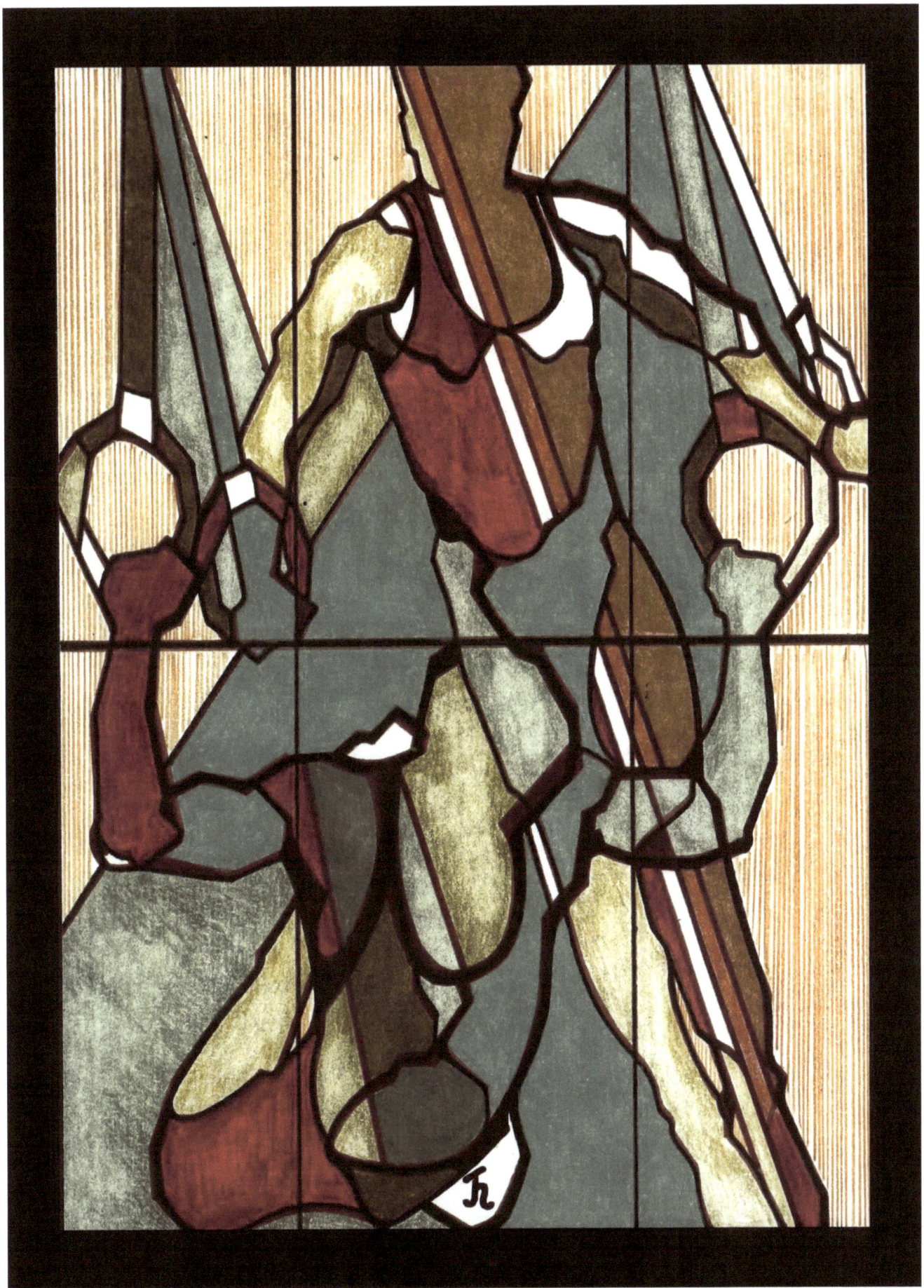

Total giving in spousal love engenders a bridge from Deity to self and spouse, propelling guidance from the Holy Spirit.

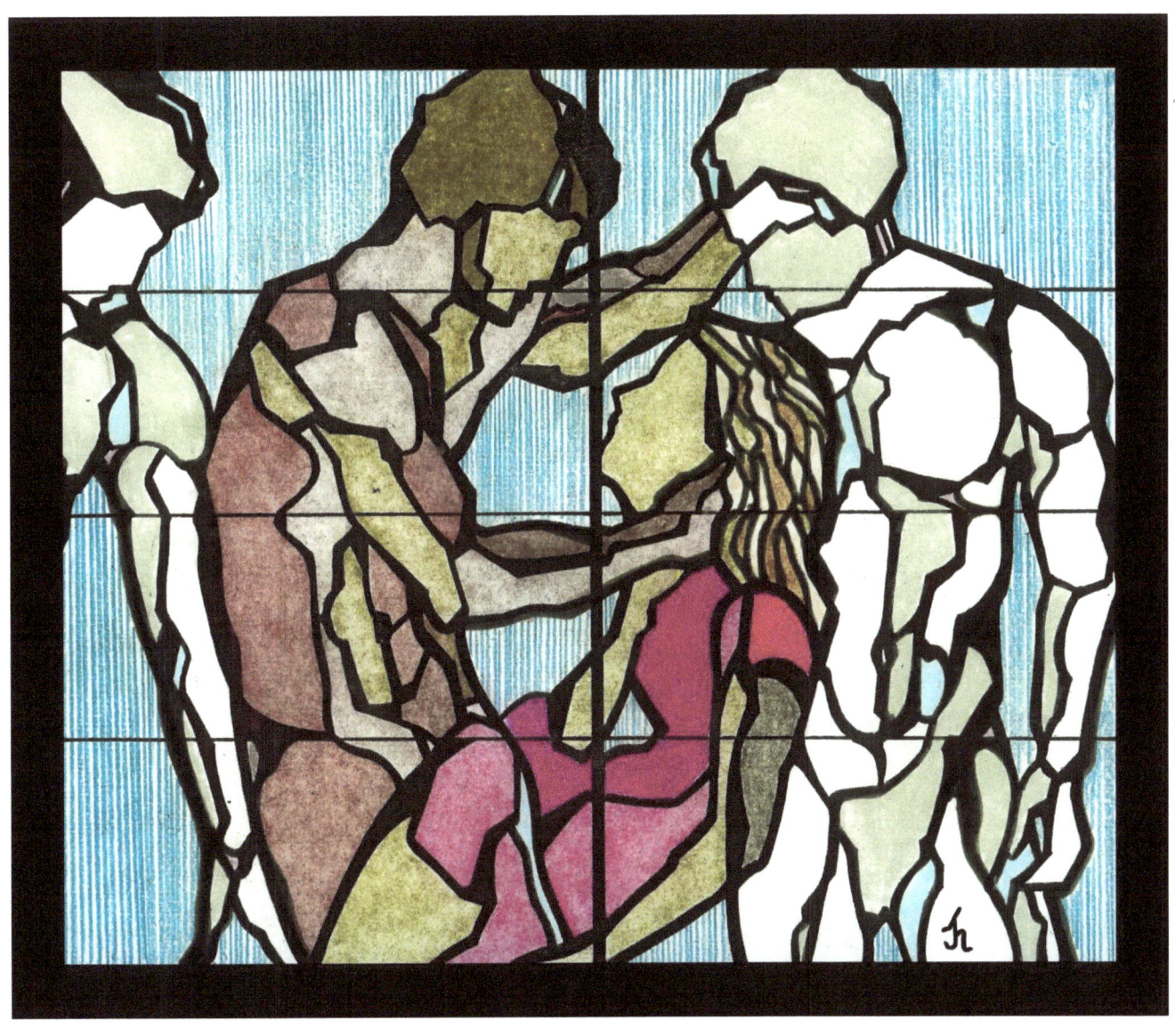

There is a beauty unsurpassed. It is your temple body— profound gift from Father God.

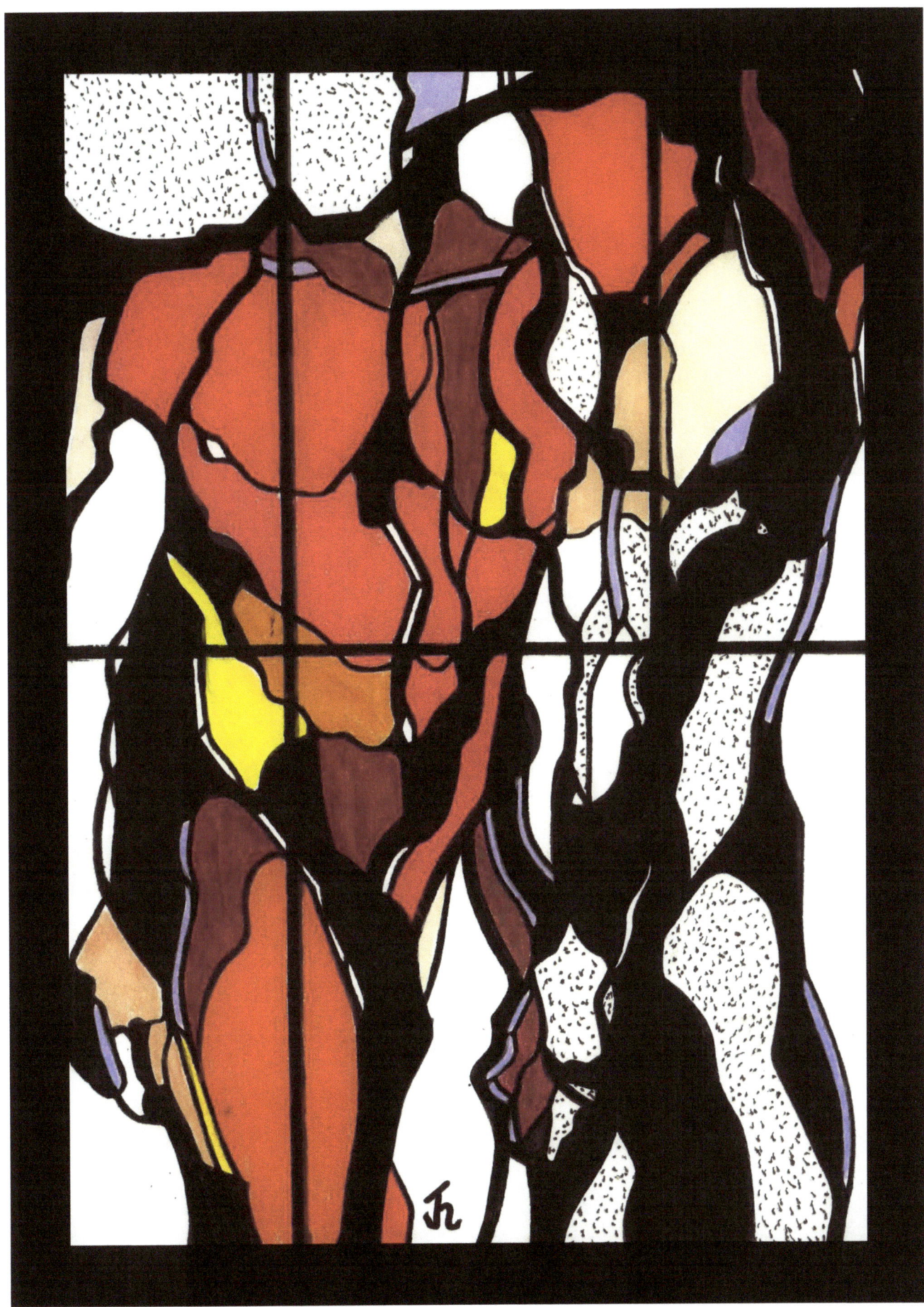

Why do we look away seeking greener pastures? Know we not that we have eternity within our grasp?

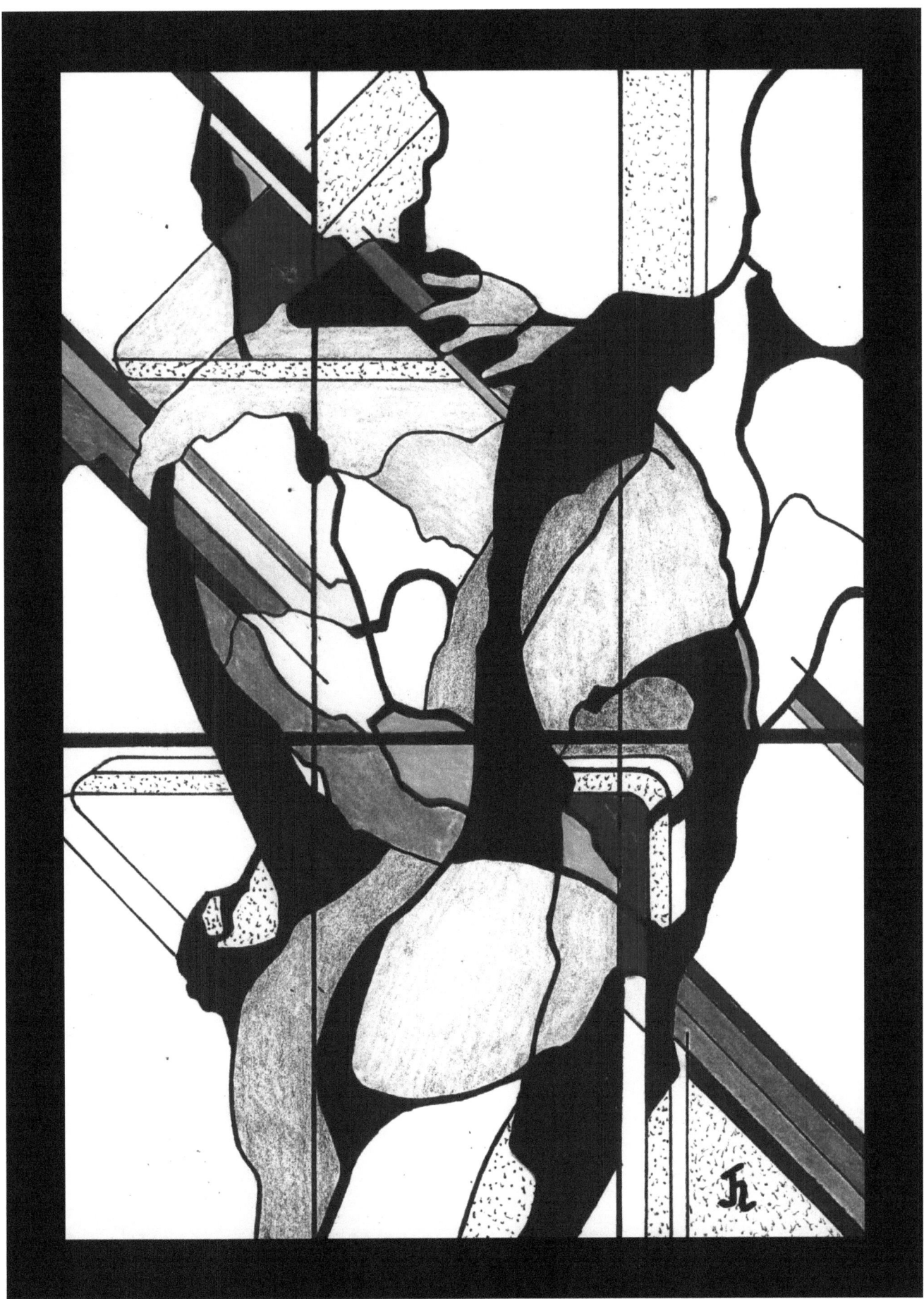

In prayer and meditation only, can we render inward judgment of our path to happiness, which is, indeed, success.

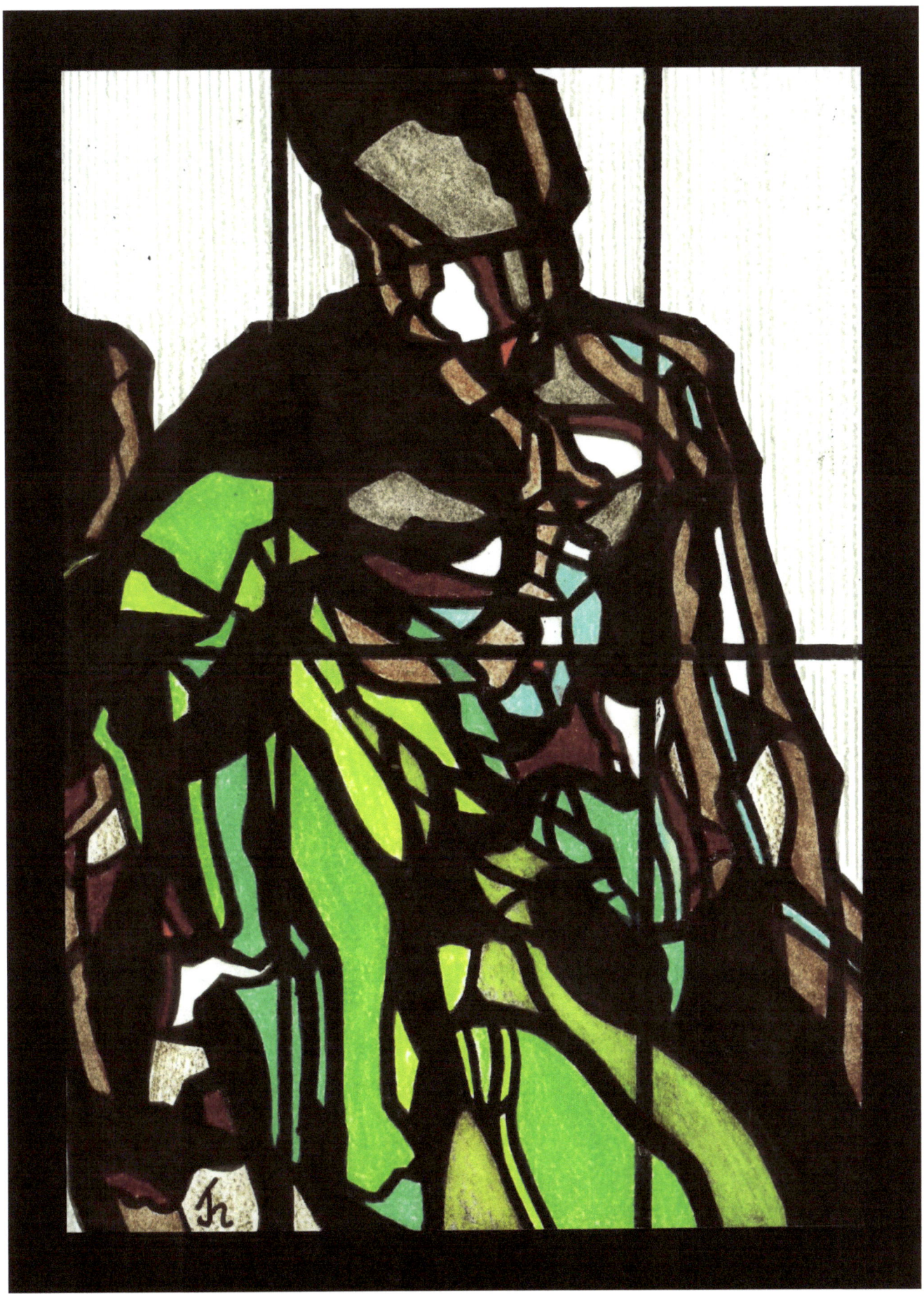

We think our knowledge is profound with so many answers. We mock humility by seeking physical power. Then, when our spirit finally bends in full contrition to hear the still small voice, we grasp how little we knew.

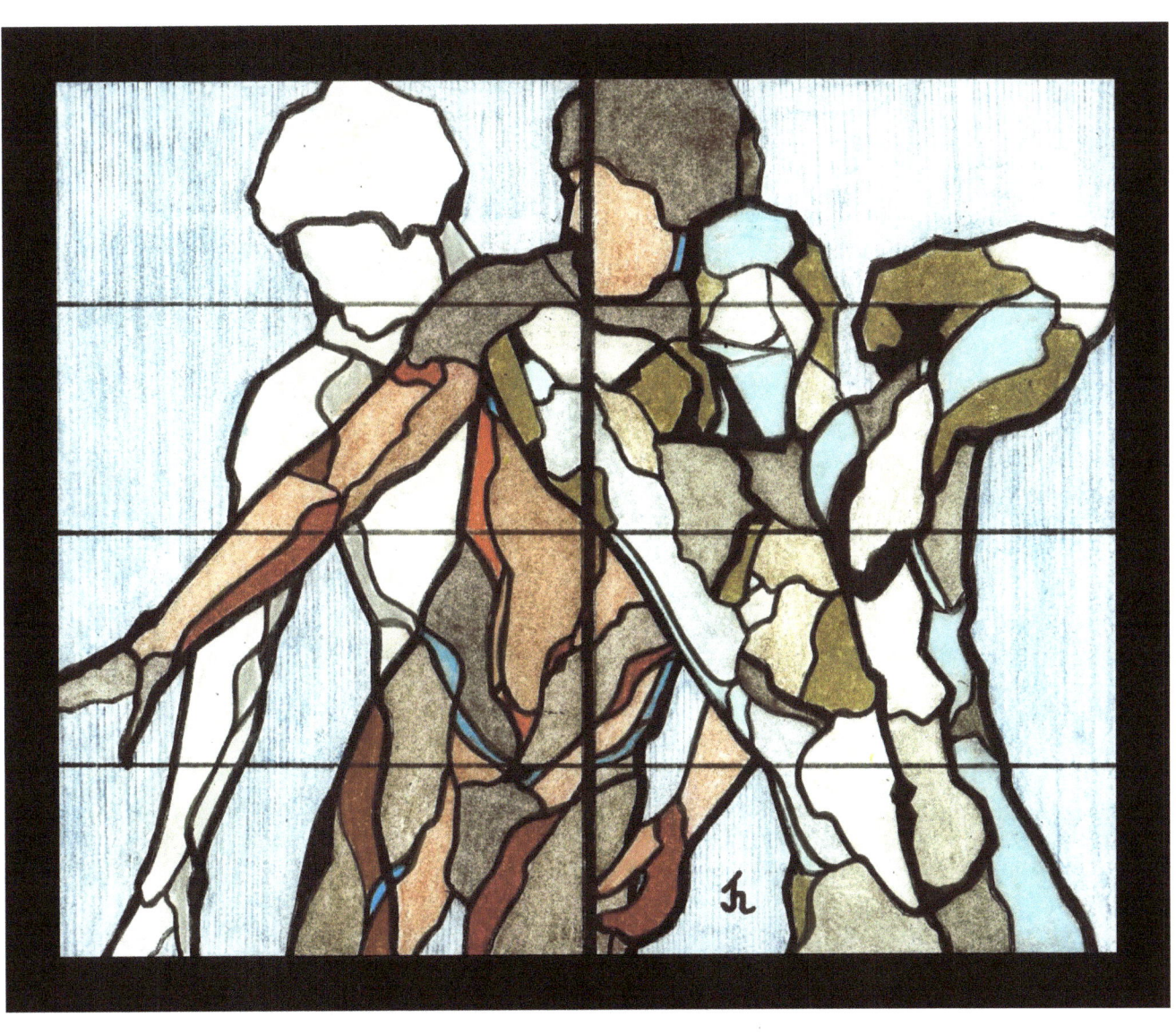

The magnitude of all our sins upon one perfect man has rocked the universe in triumph for mankind. His arms raised high upon the cross won victory over the grave.

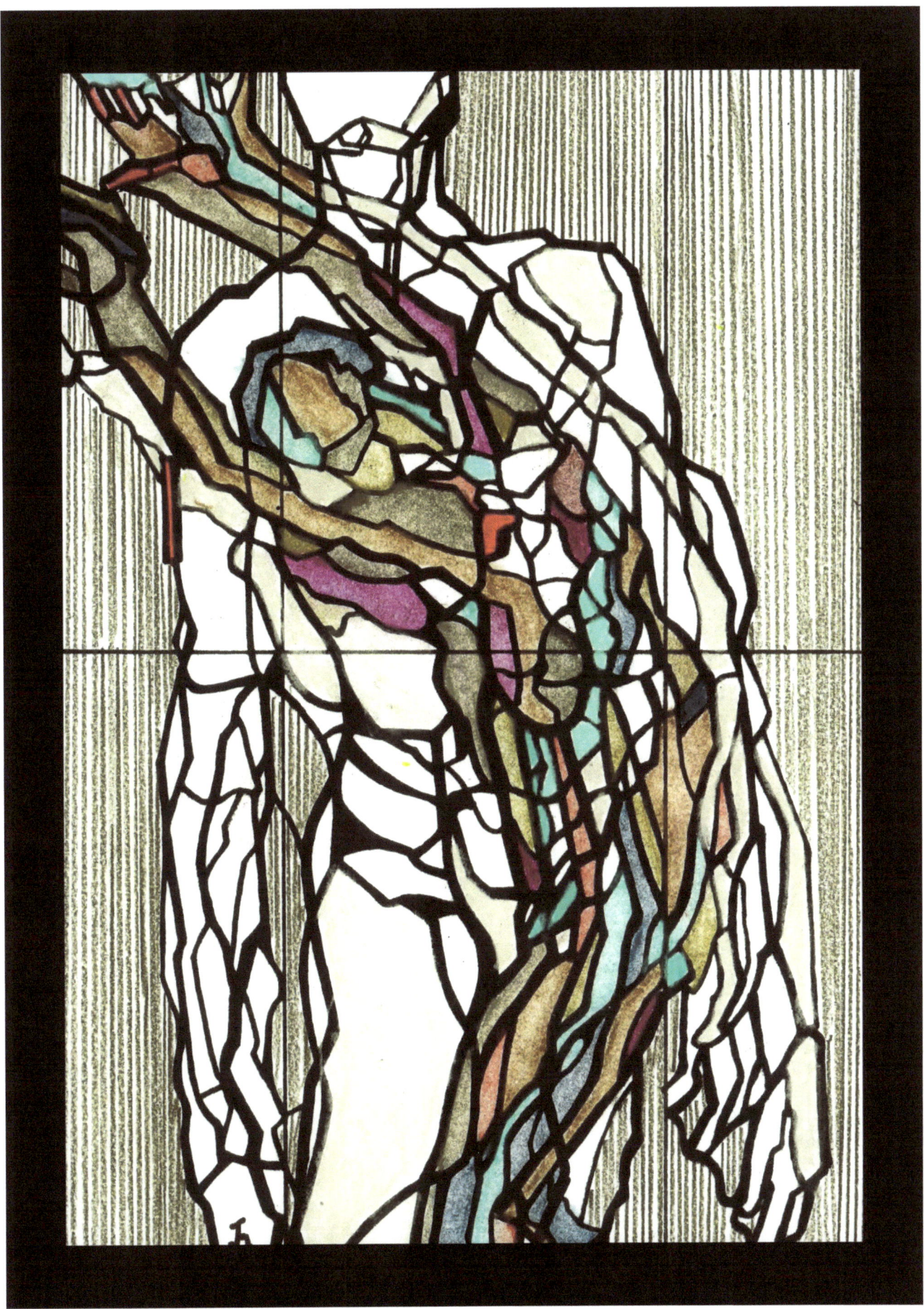

The swaggering of vanity and pride requires no thoughtful discernment.
It welcomes carnal force within.
The spirit finds the balance to overcome.

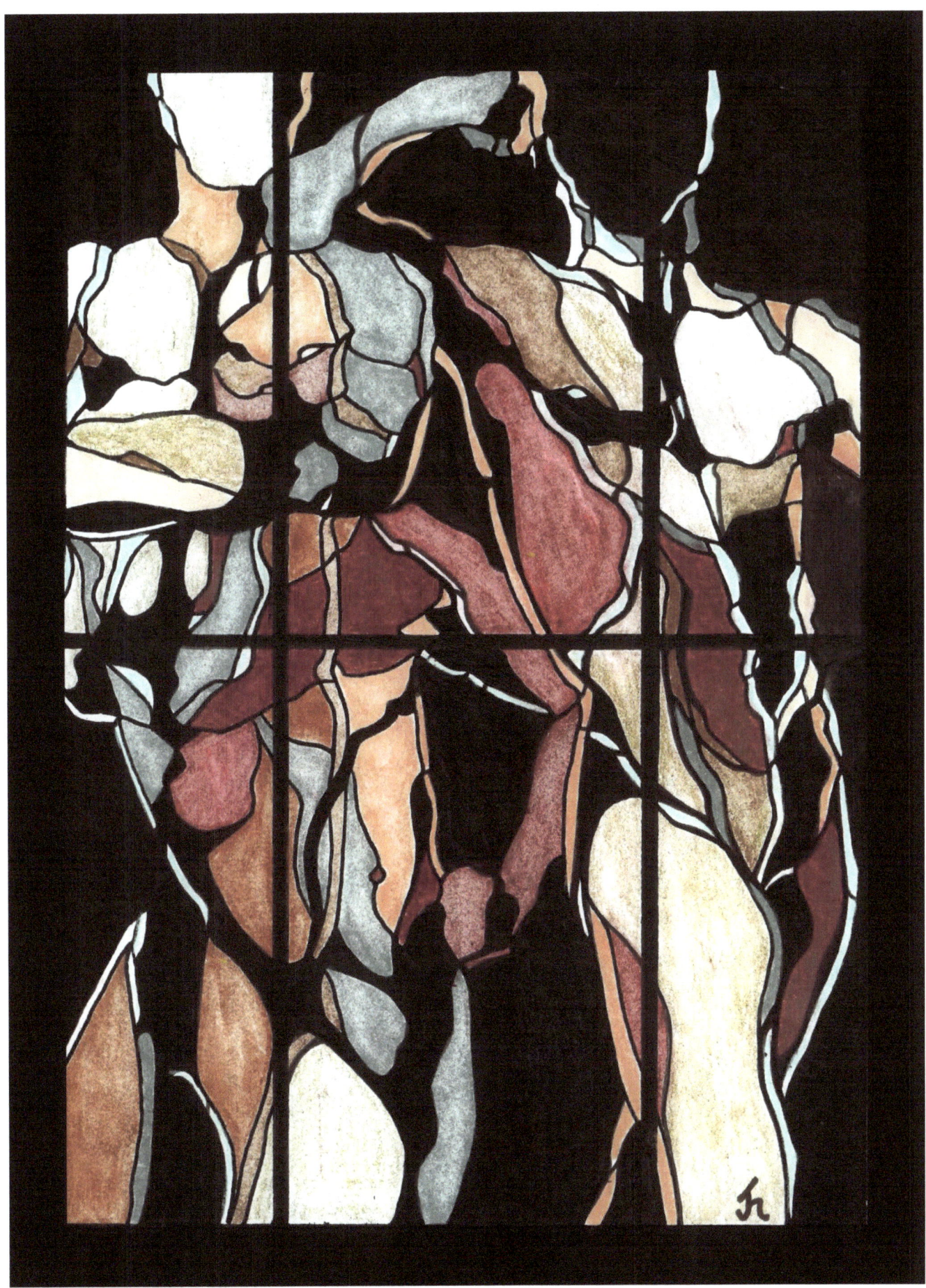

The need to plead for help and guidance comes to all; but when we fail to know God's hand in all things, we fail to understand His timing.

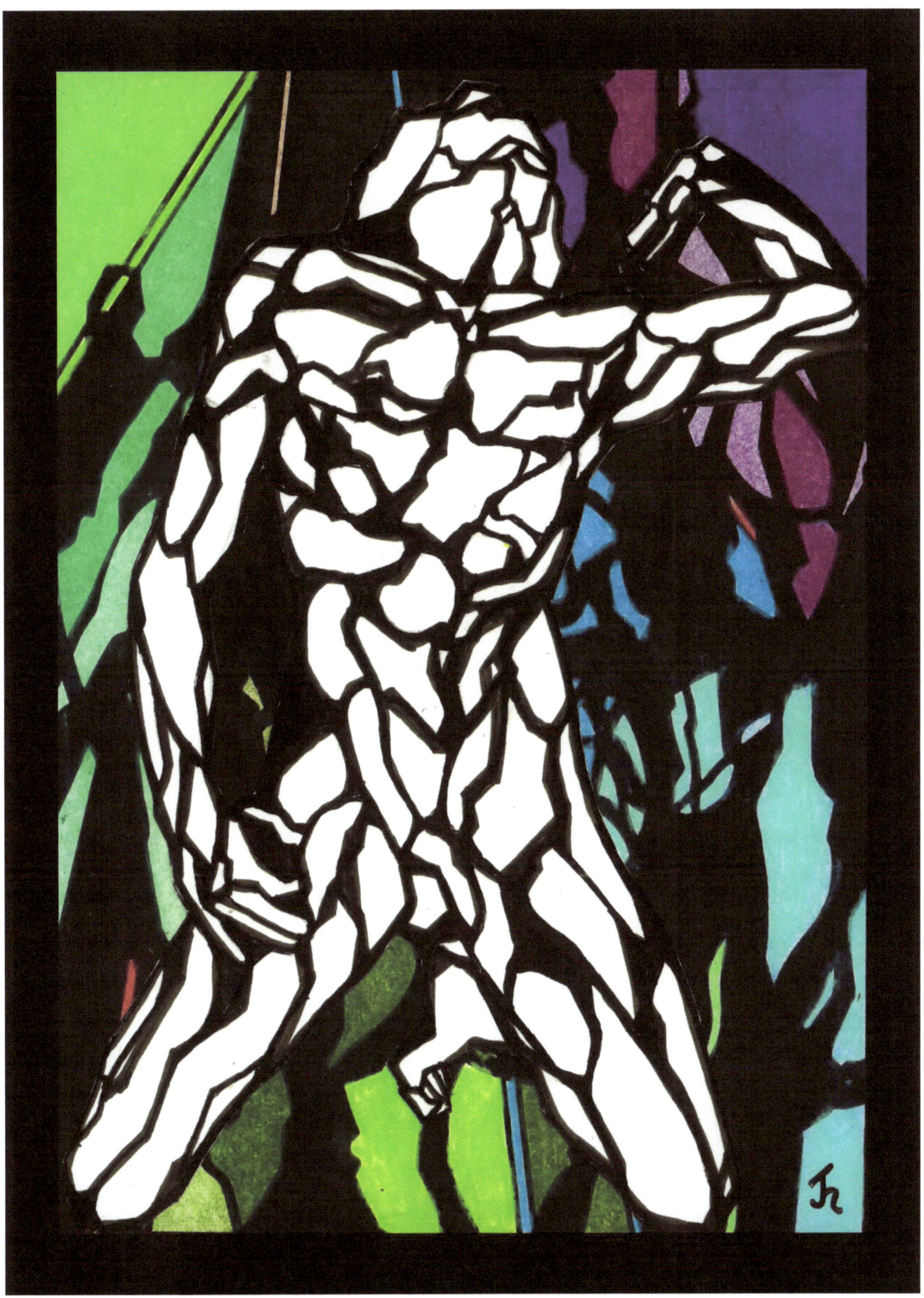

**The upward climb
of Earth life's little day
rewards us with
eternal joy!**

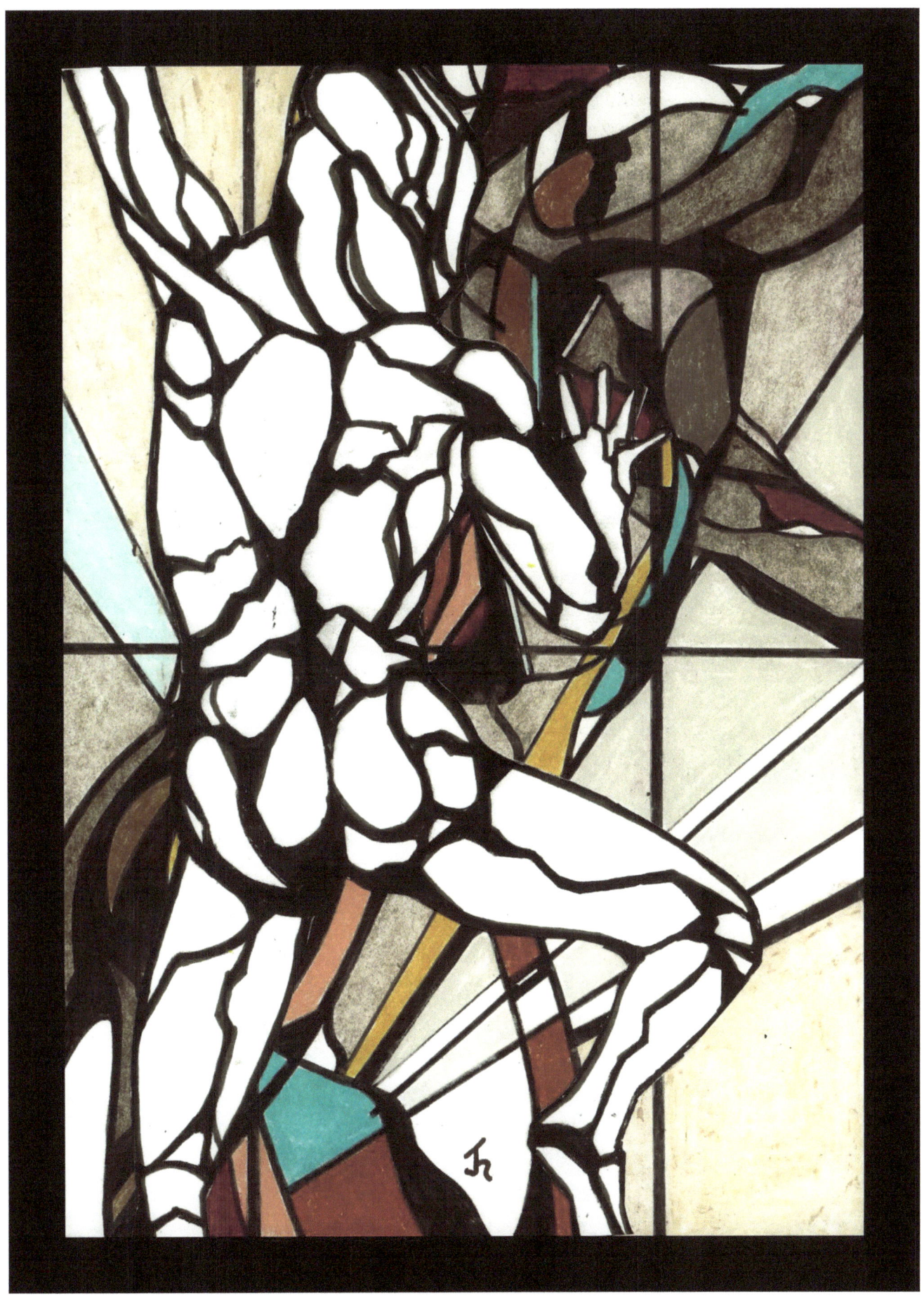

We fall within the web of imagery that multiplies desires for things that ultimately bring pain.

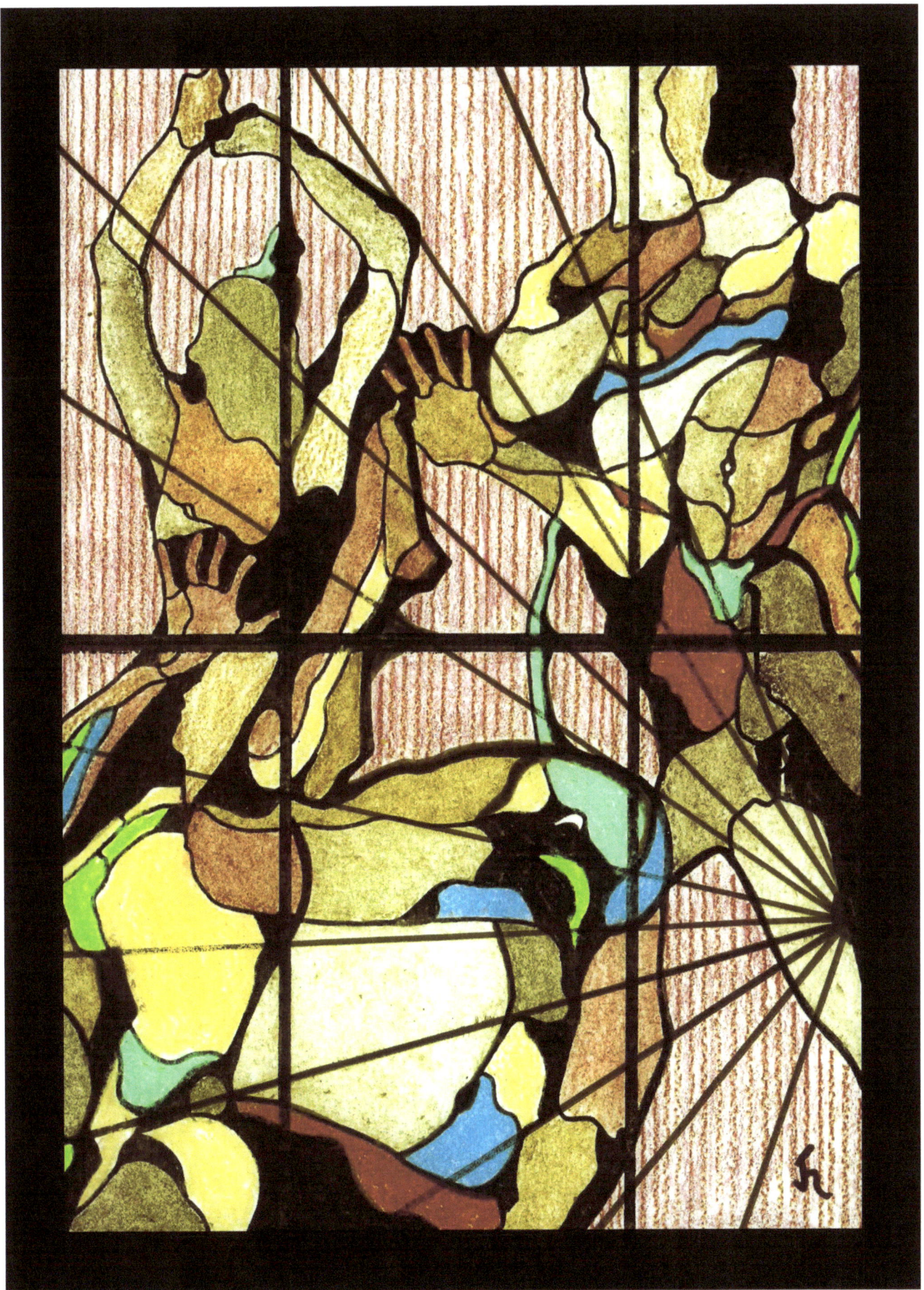

Our vanity displays our insecurities, yet hides our longing for a spiritual union with our Savior's love.

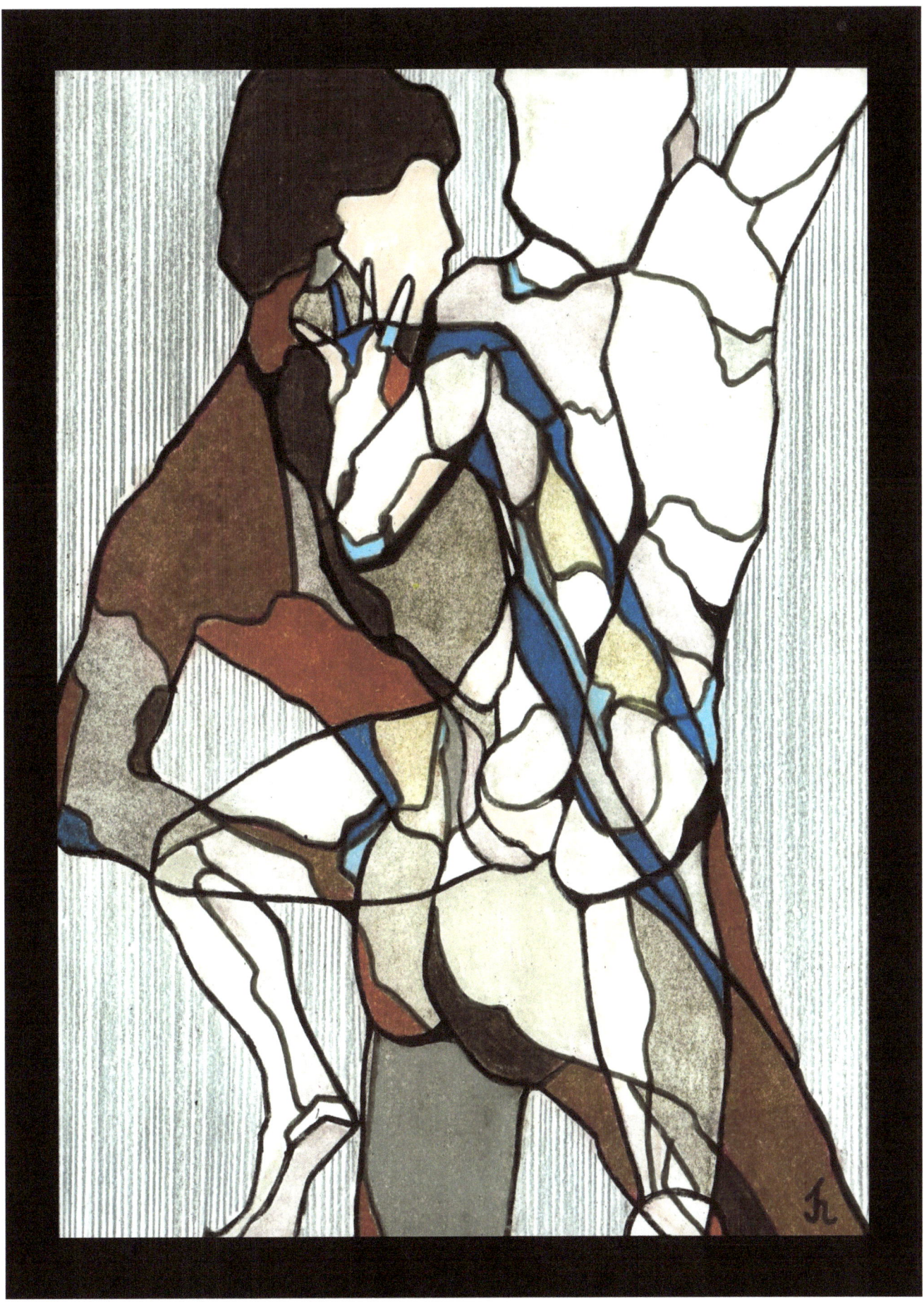

A bulwark of protection
stands about us.
Let us hold to it
like an iron rod.
It brings the sweetest
purest fruit.

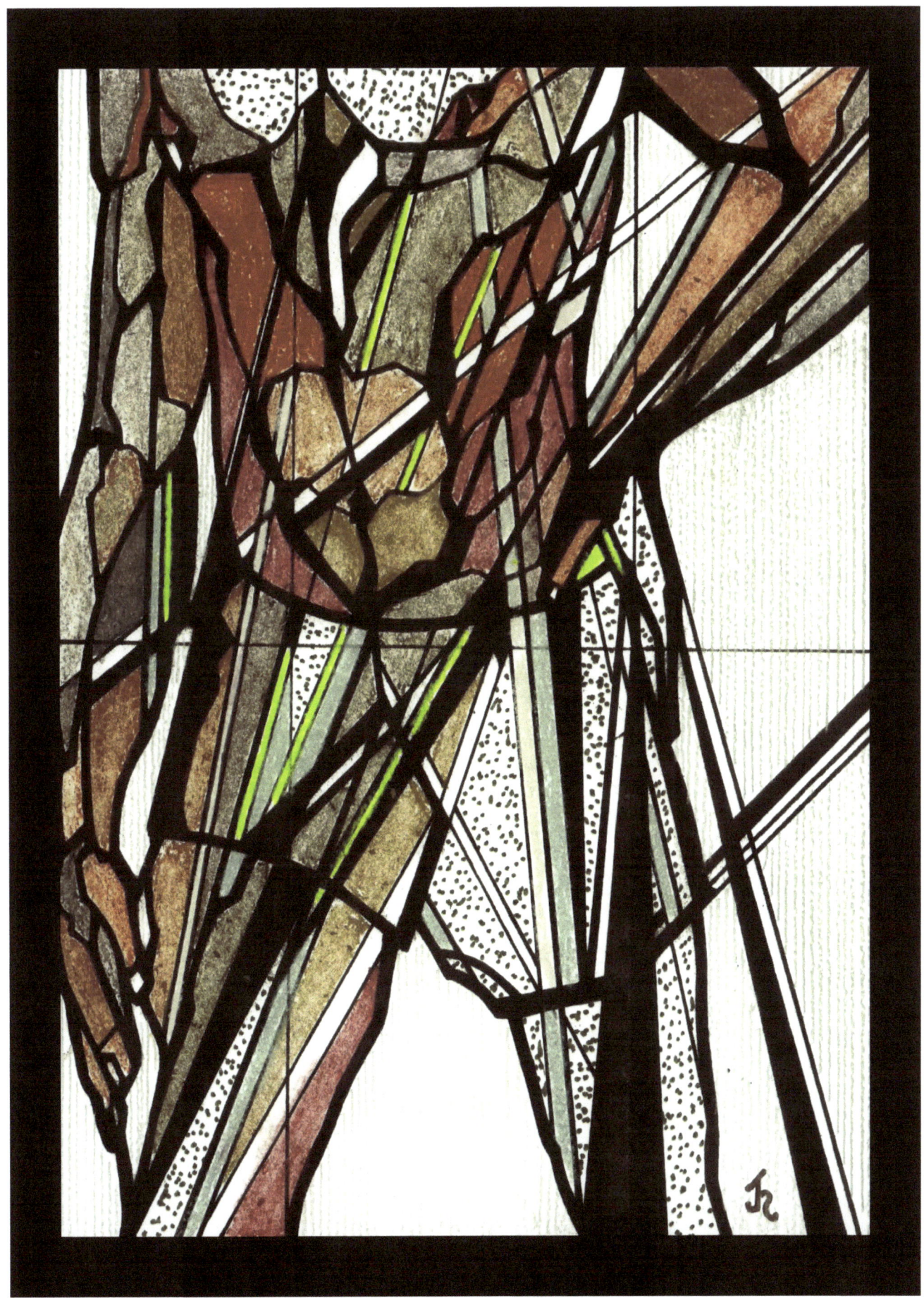

**Toil brings joy to spirit,
body, and intellect,
causing expansion
for the good of all.**

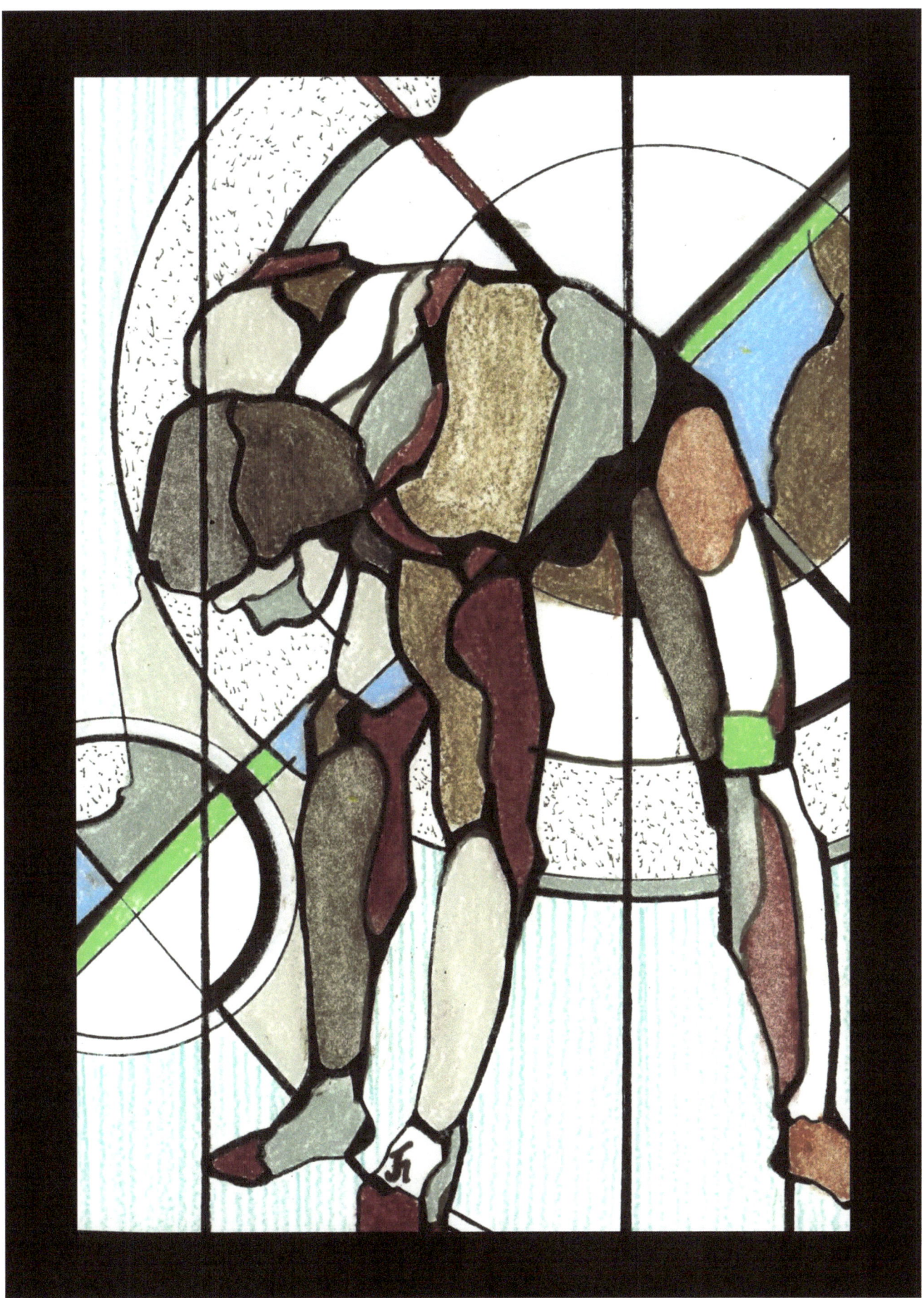

We each harbor a plethora of faces. Only one, in similitude of Deity, lifts to joy eternal.

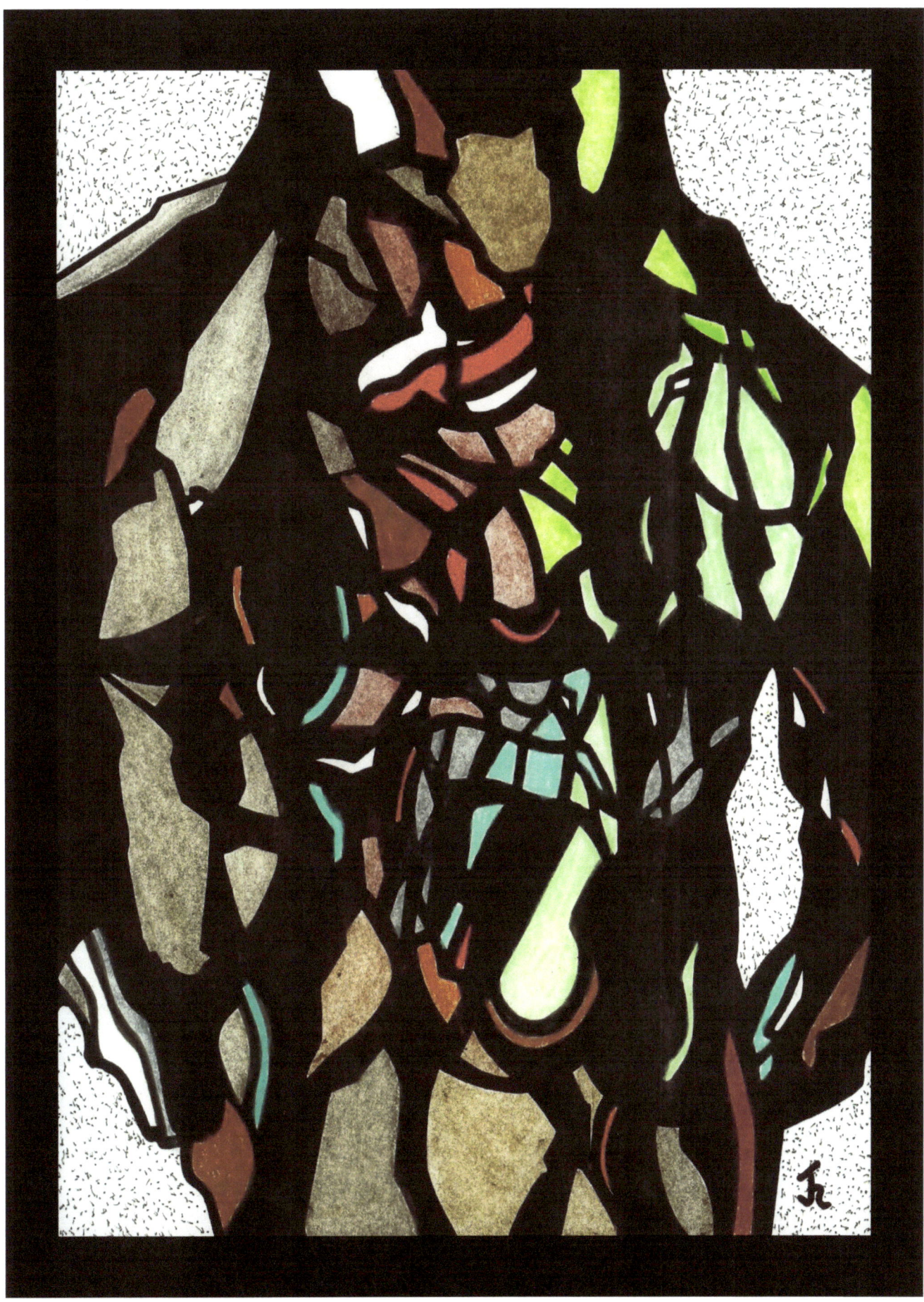

The human body, a temple to the Most High, will become eternal.

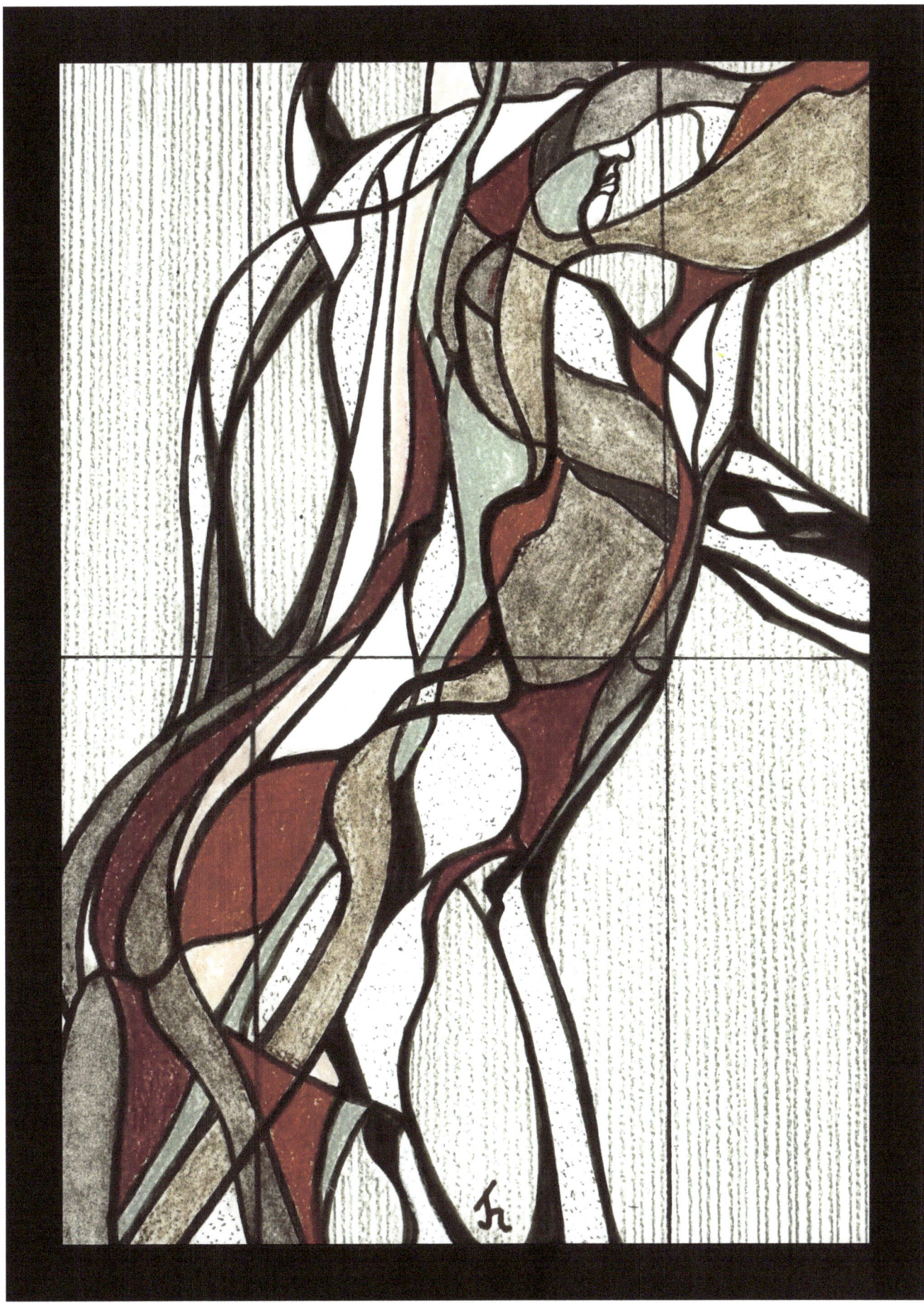

The human spirit yearns to float above the earthbound natural man.

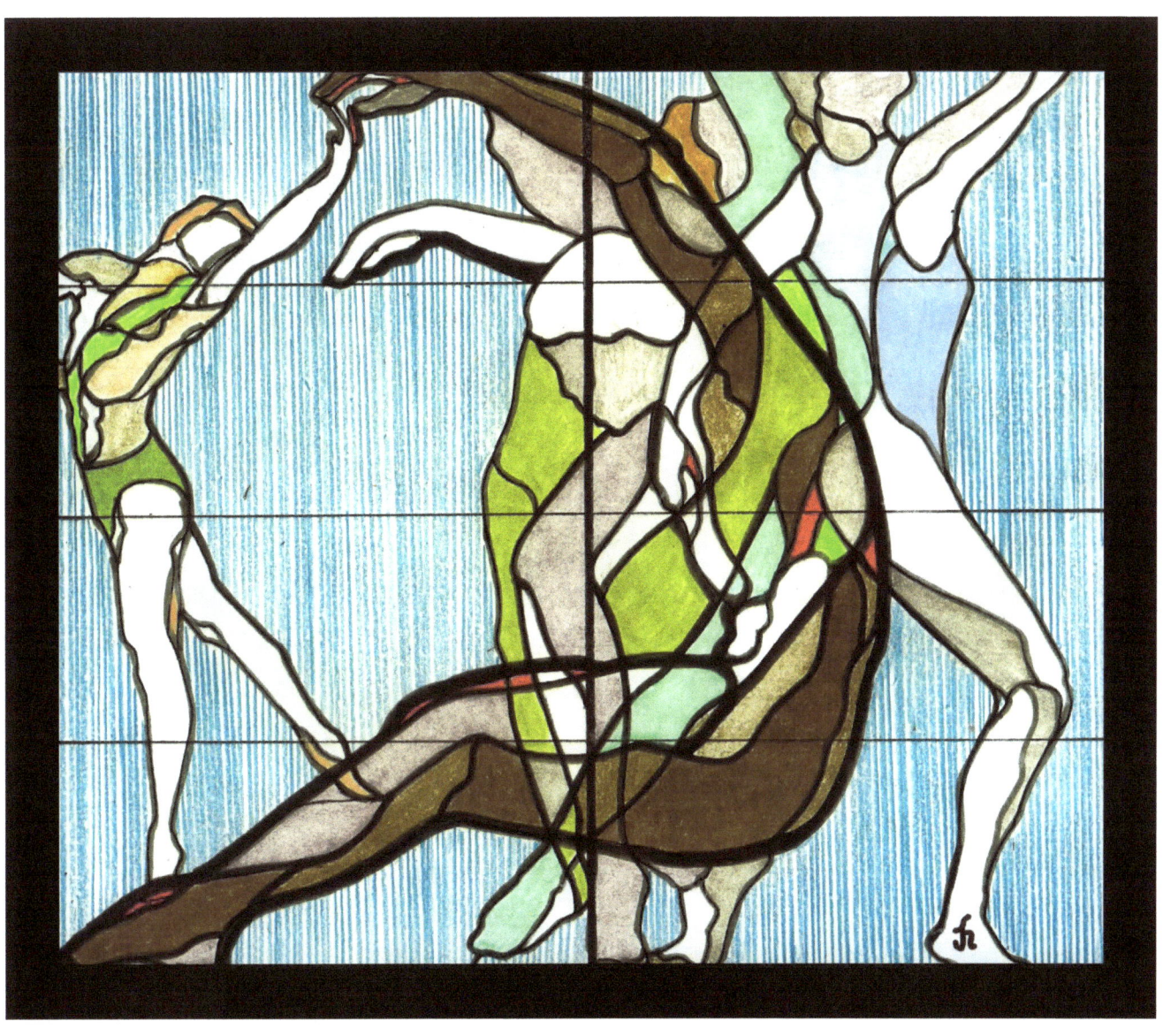

Life suspends us between the gamut. We may choose up or down, but cannot stay constant. Our eyes function in the light; but in darkness, truth is shrouded. Shall we look downward to the abyss, or upward in nobility?

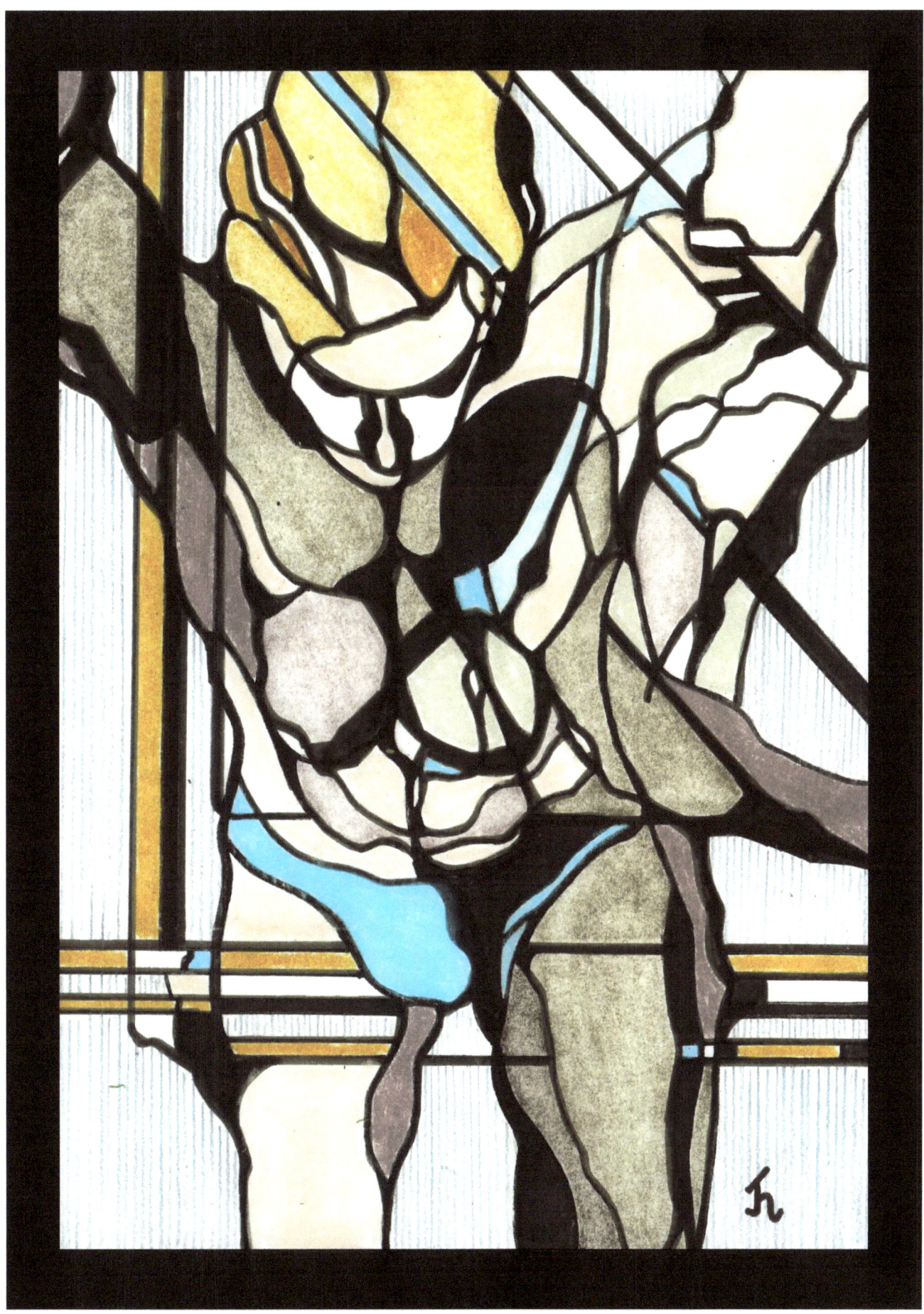

Our energies explode to show our depth of feeling through the dance.

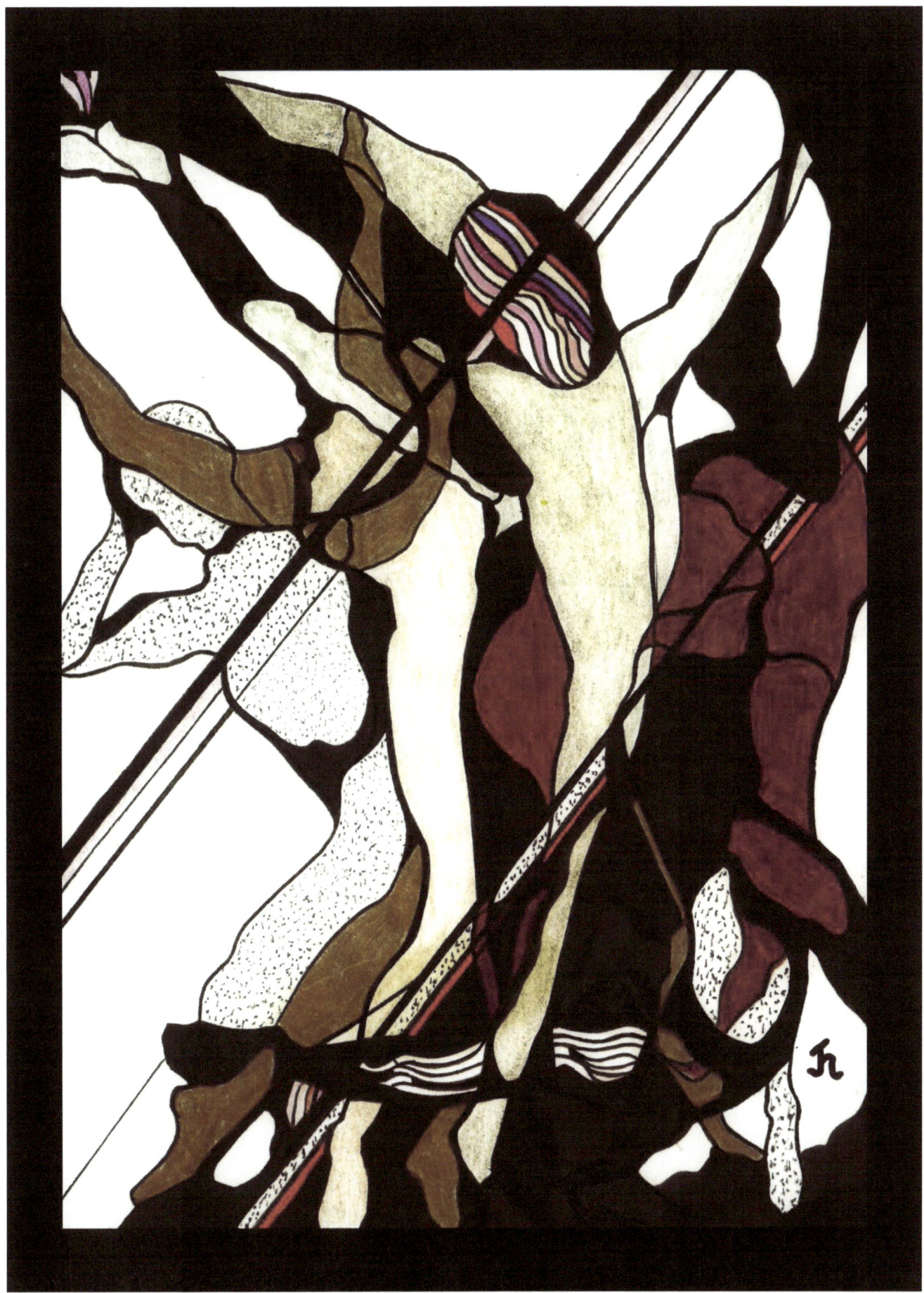

Duality is rampant in us all. We seek to know the truth, but fight it when we see it clearly. If the price is but little, we find it far too much to pay.

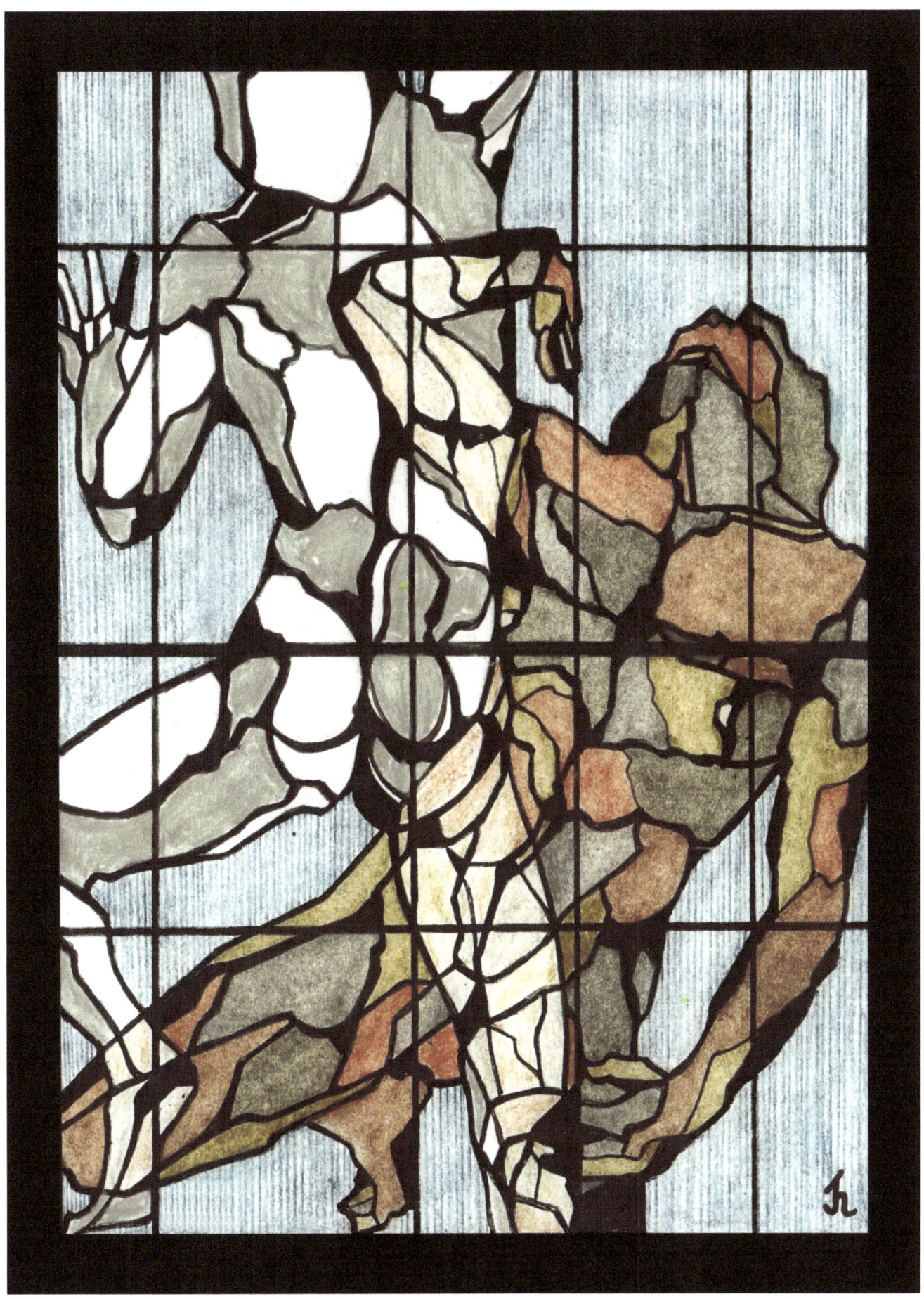

All are flooded in the light. Yet, some look toward darkness. Others pretend to see, but seek not. The noble consume its blessings and thrive on inspired truth.

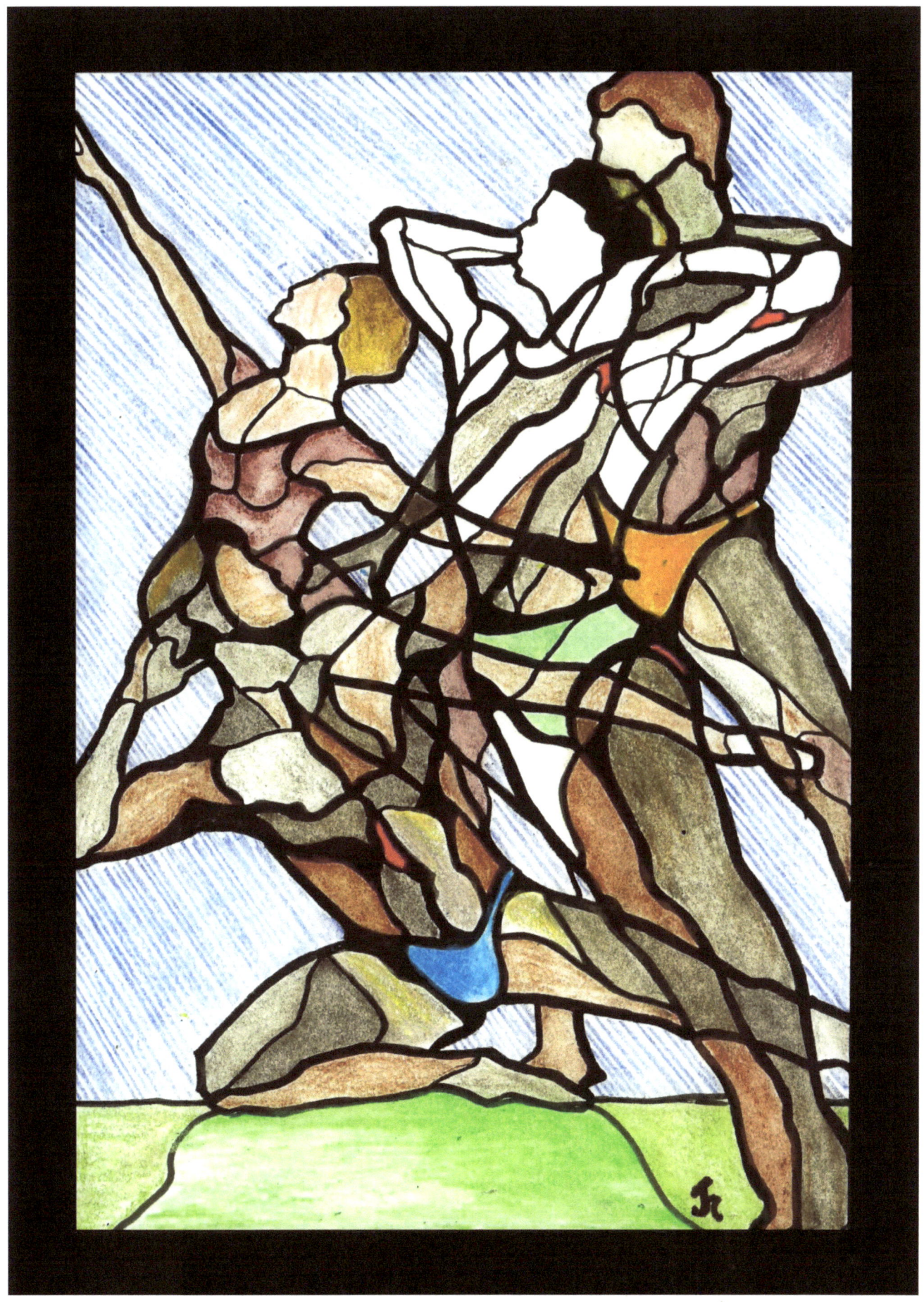

We strut and pose like peacocks to impress, but fail; for peacocks do it best.

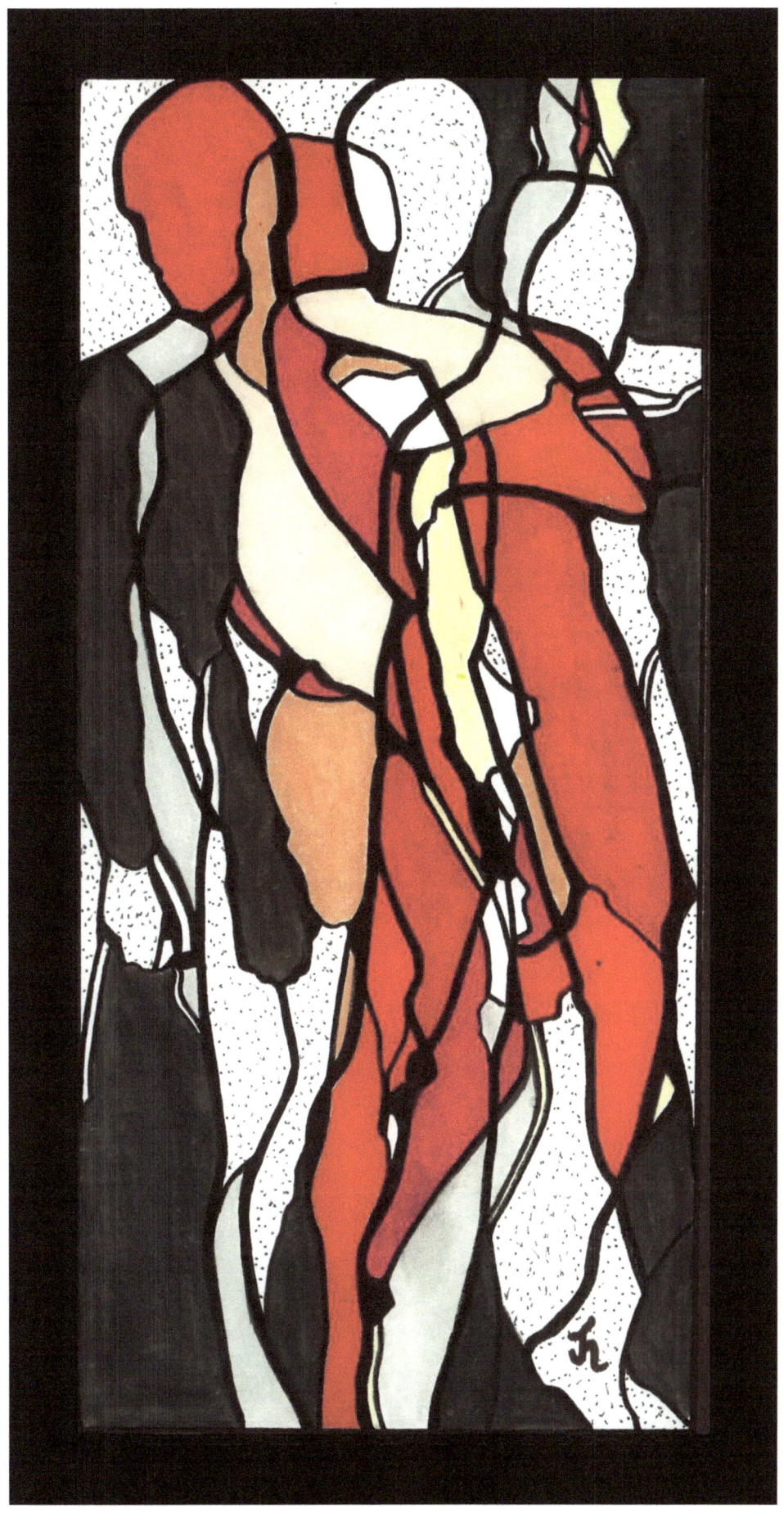

Pictures explode and drench the mind with imagery that sweeps our actions into play.

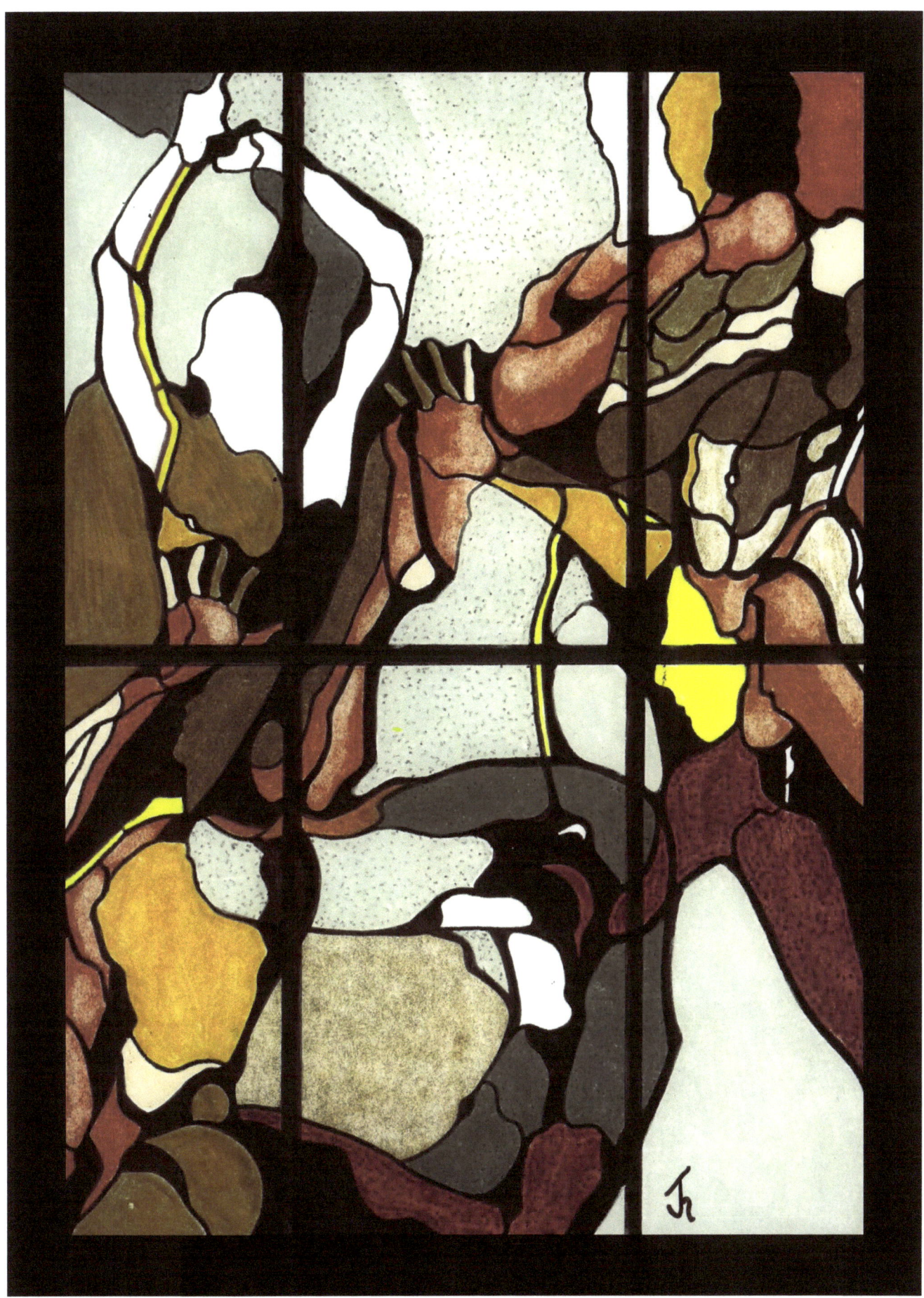

**Life's upper climb
is fraught with
rust and barbs.
It takes the deepest
faith to recognize
the blessing of
Refiner's fire.**

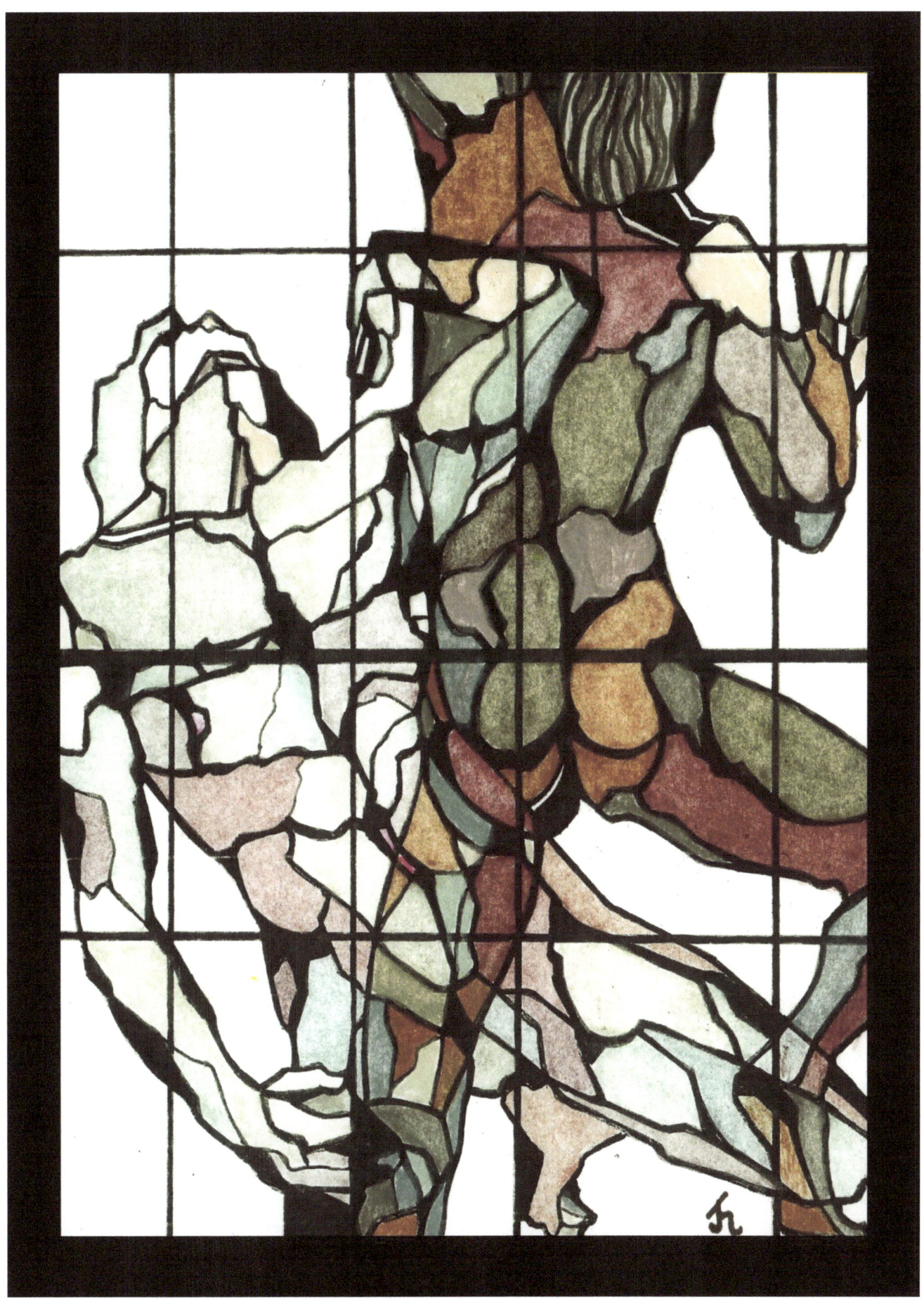

All hail to Father Adam and his Eve!
Cast from the garden's ease, they trudged to build God's earthly kingdom in sweat and tears. What courage did it take to build and bring forth progeny instead of choosing passive pleasures without the joys
of what could be?

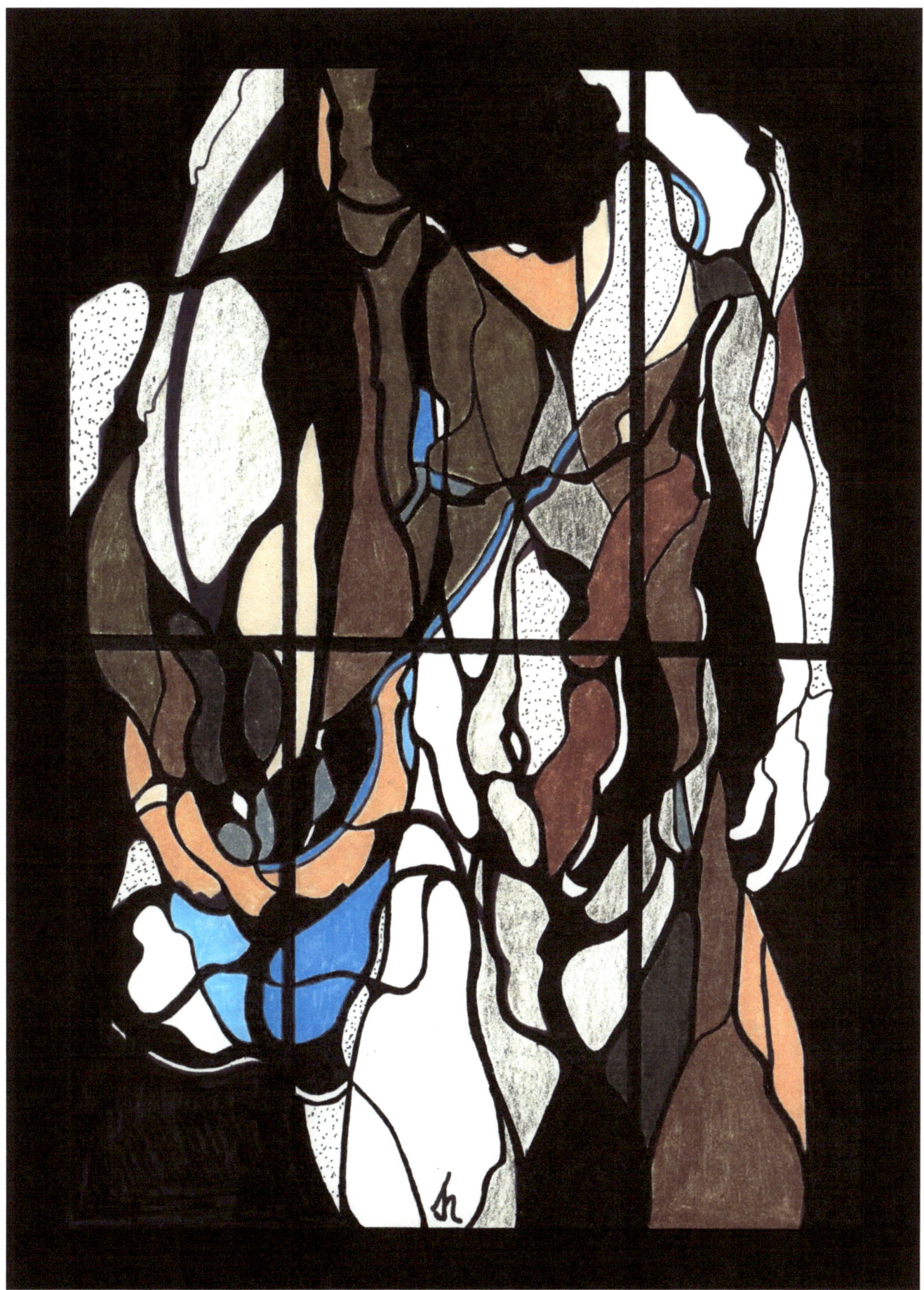

The progeny of Eve and Adam face the blaze of hot refiner's fire, and will endure to taste the precious fruits of eternal life with a resurrected body in the image of Creator God.

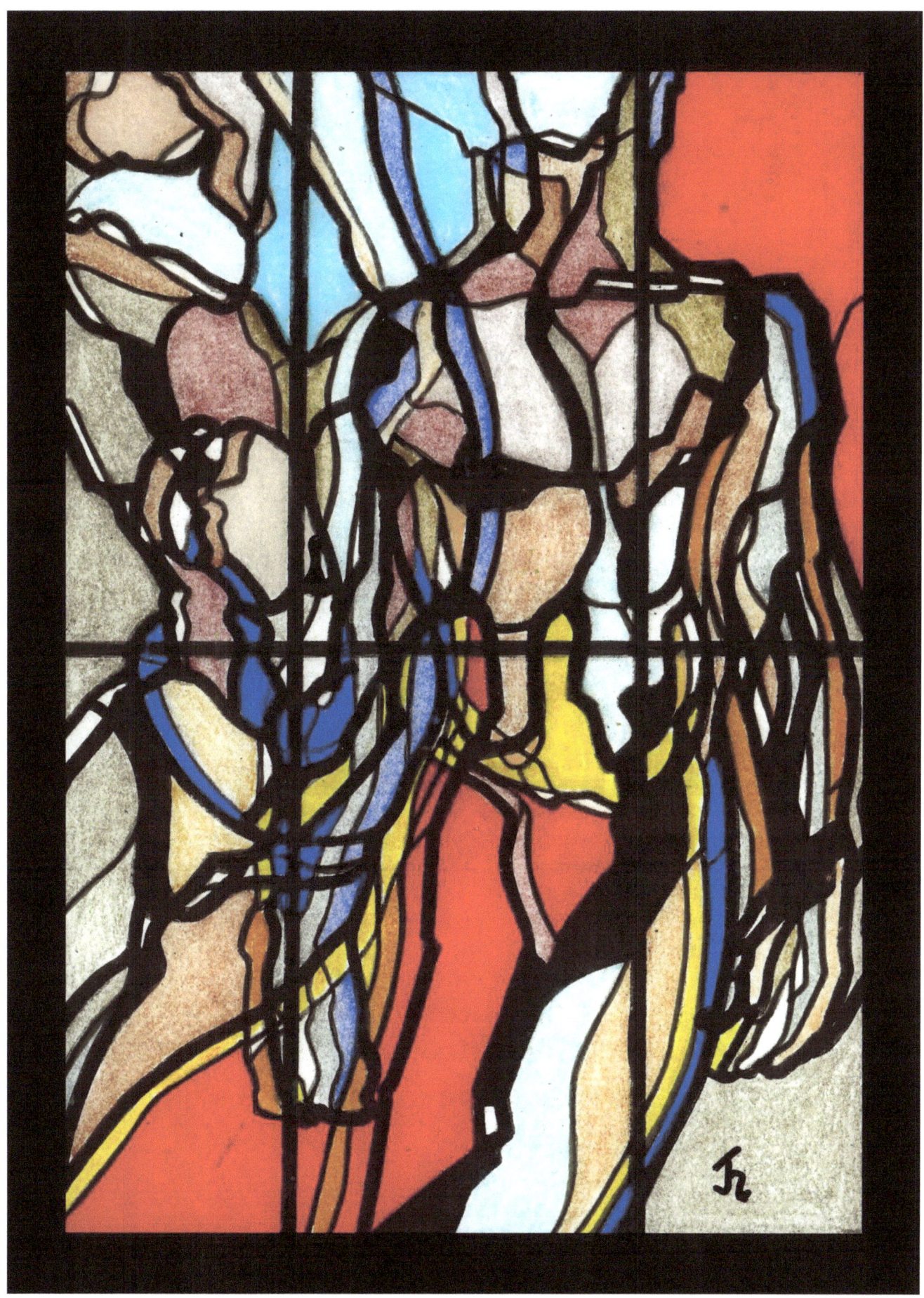

We hold the keys to recreate our bodies in the splendor of their finest hour through the atonement of Christ Jesus! Satan and his angels yearn for such, but cannot seize.

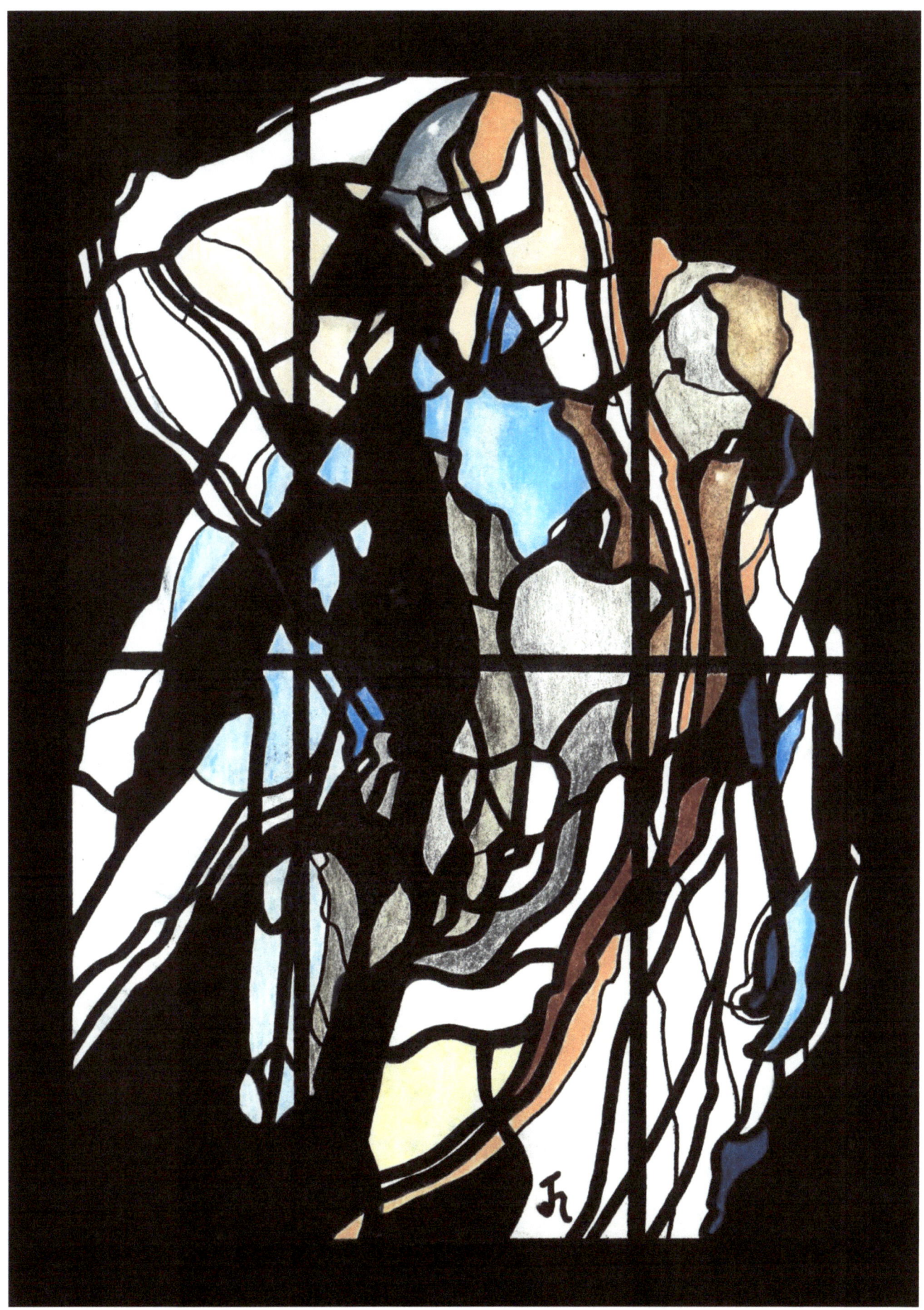

Desires devour our clarity of thought. When we neglect to seek true guidance from above, we push away the spirit to embrace the seeds of despair.

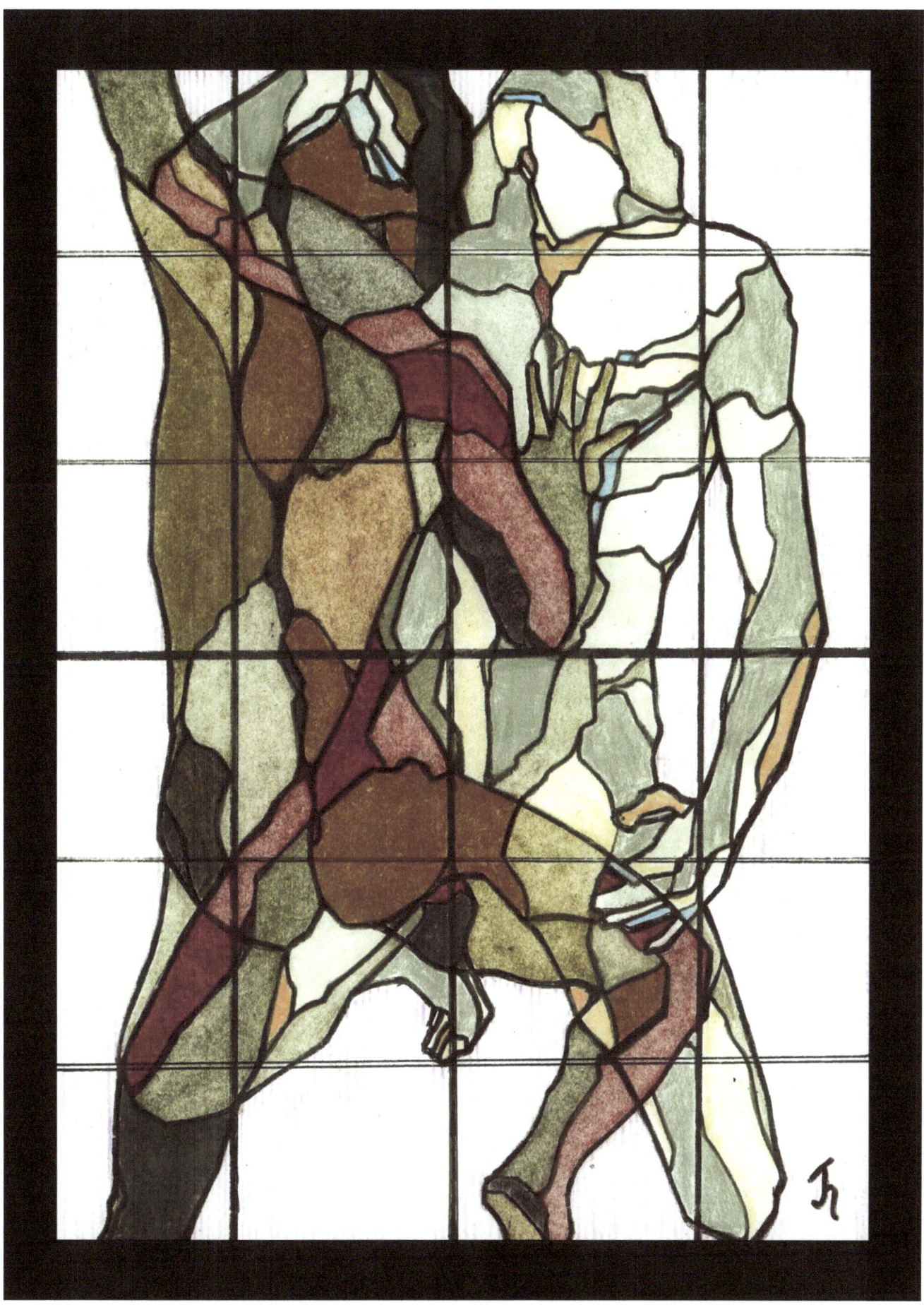

**If I look away,
how can I be
held responsible
to seek the light?**

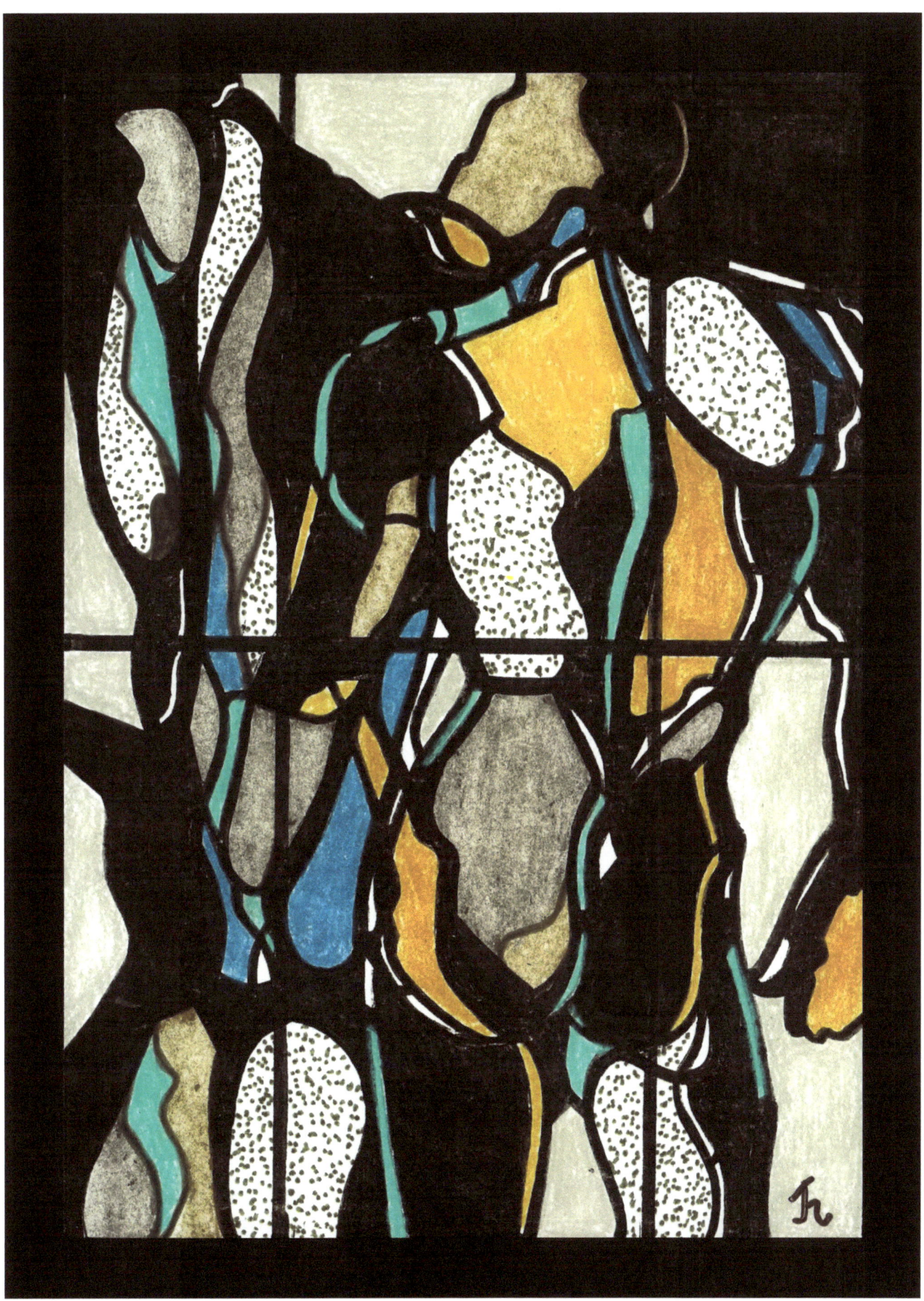

The sensitive expression of dance is shown only when driven by the spark of godly inspiration.

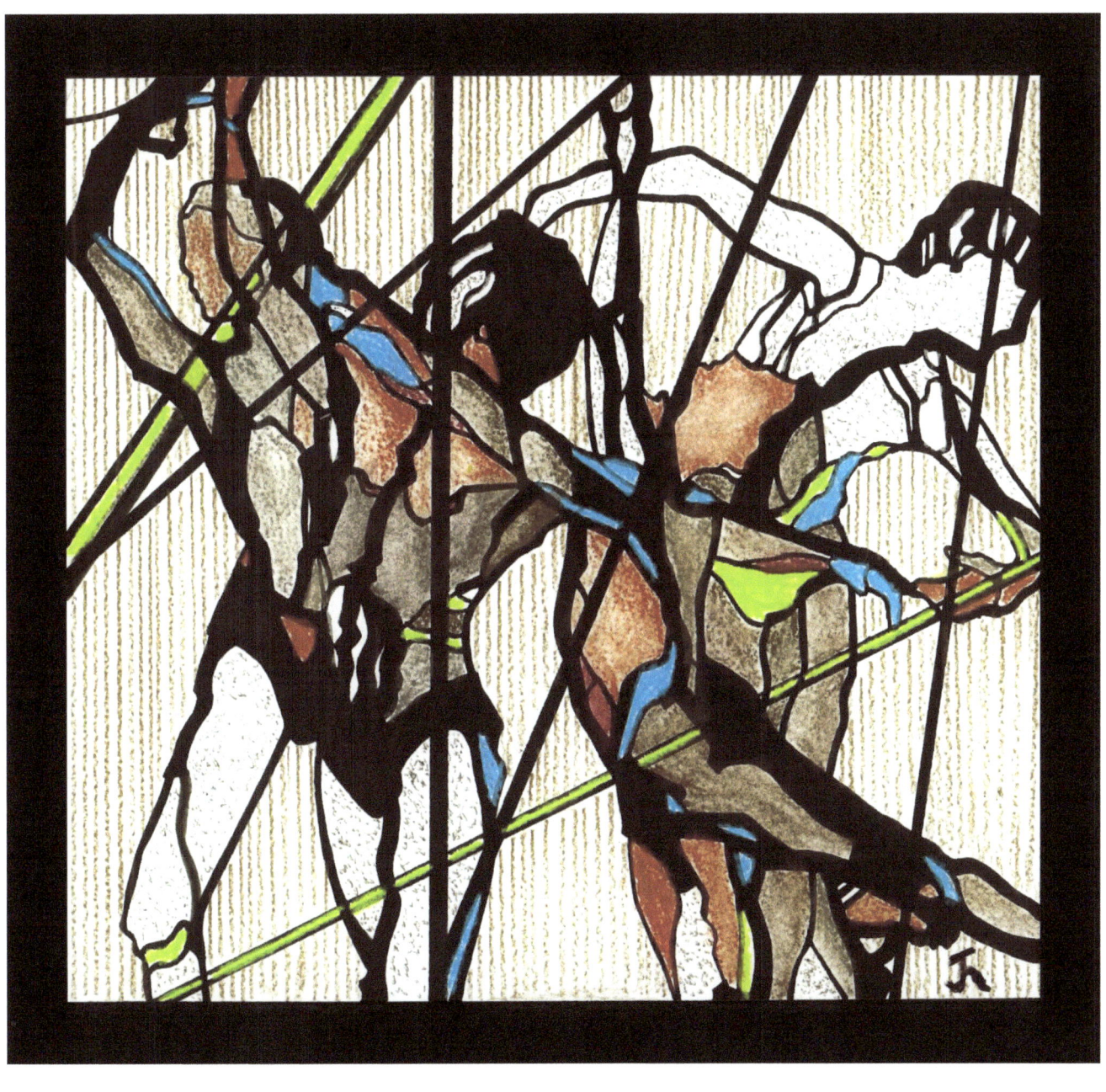

God's work is the intricate relationships of organized continuum.

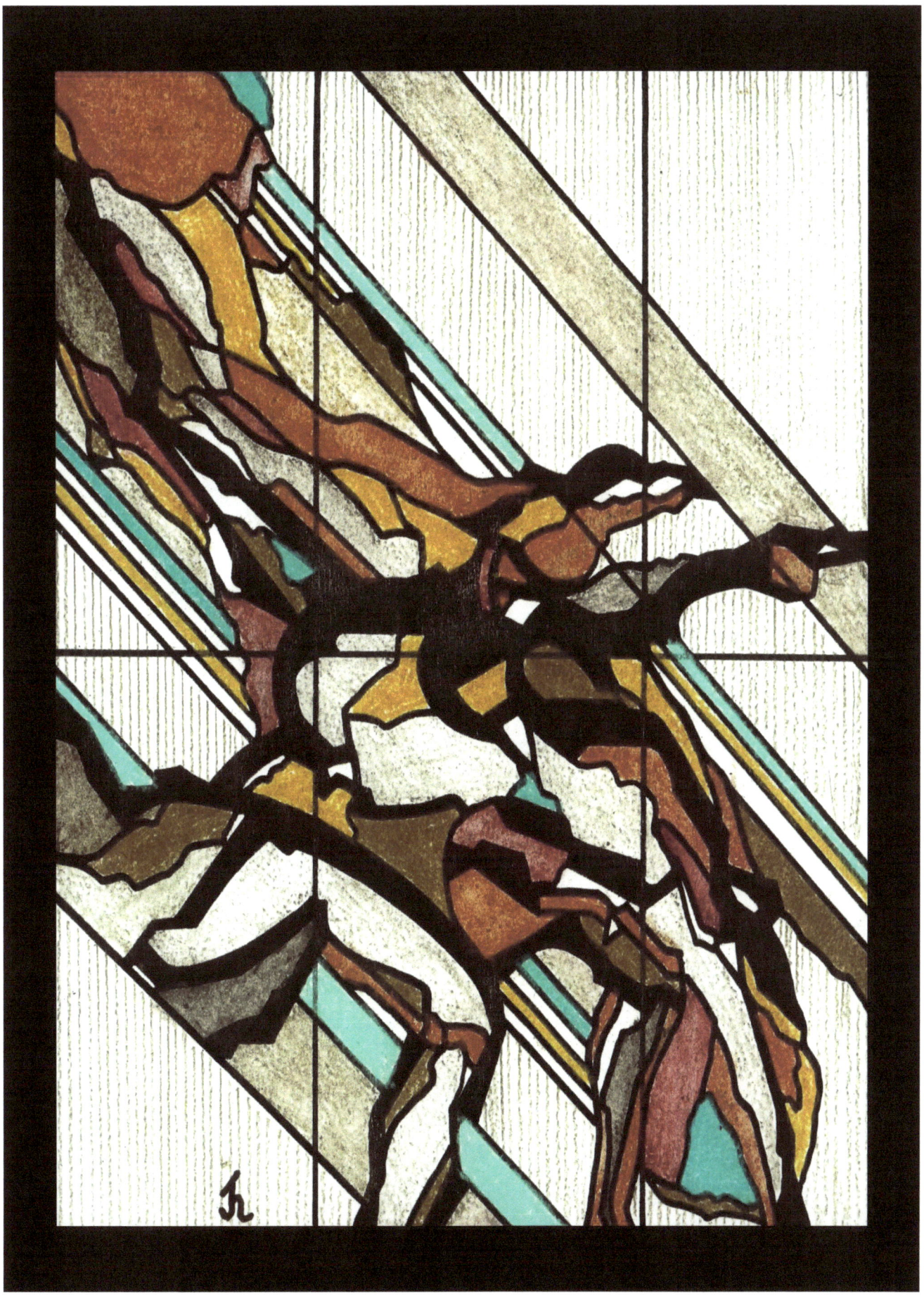

Caught in the web of procrastination, we wait too long to let our spirit guide.

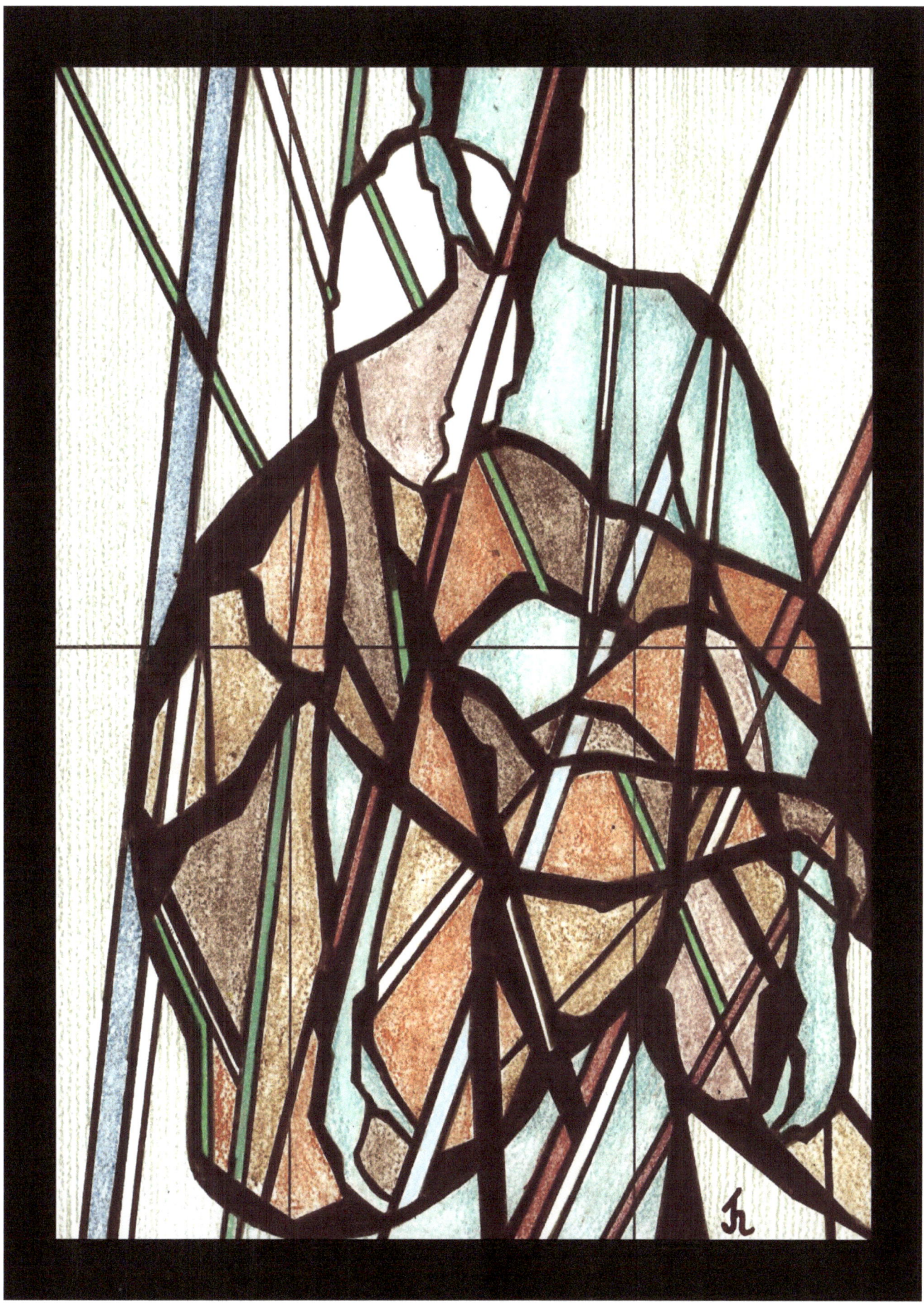

The joy of light is lost as we bathe our thoughts in darkness. Turn toward the light!

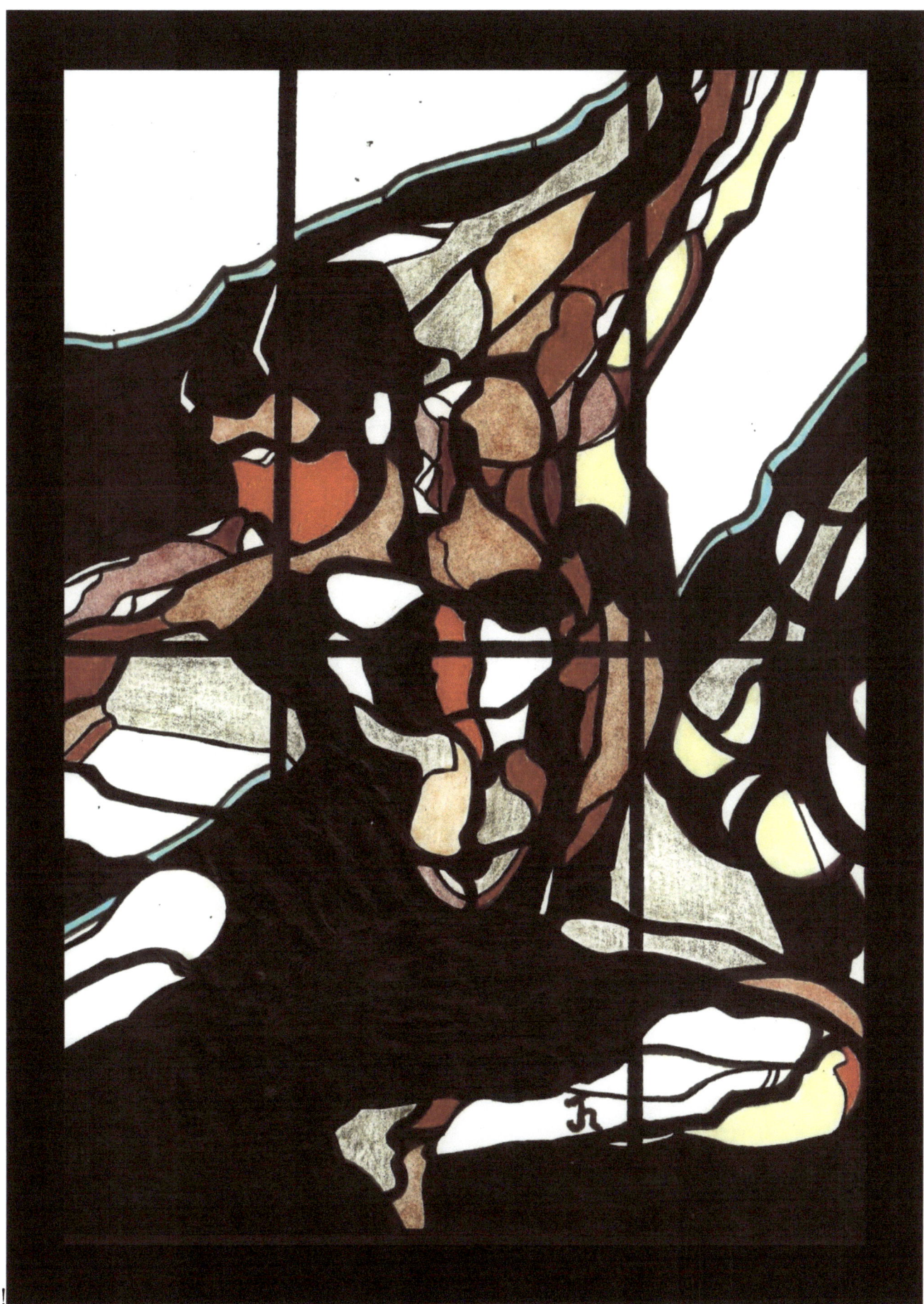

Swept away
by the crowd!
What foolishness
is this when
we leap like
lemmings over
a cliff.

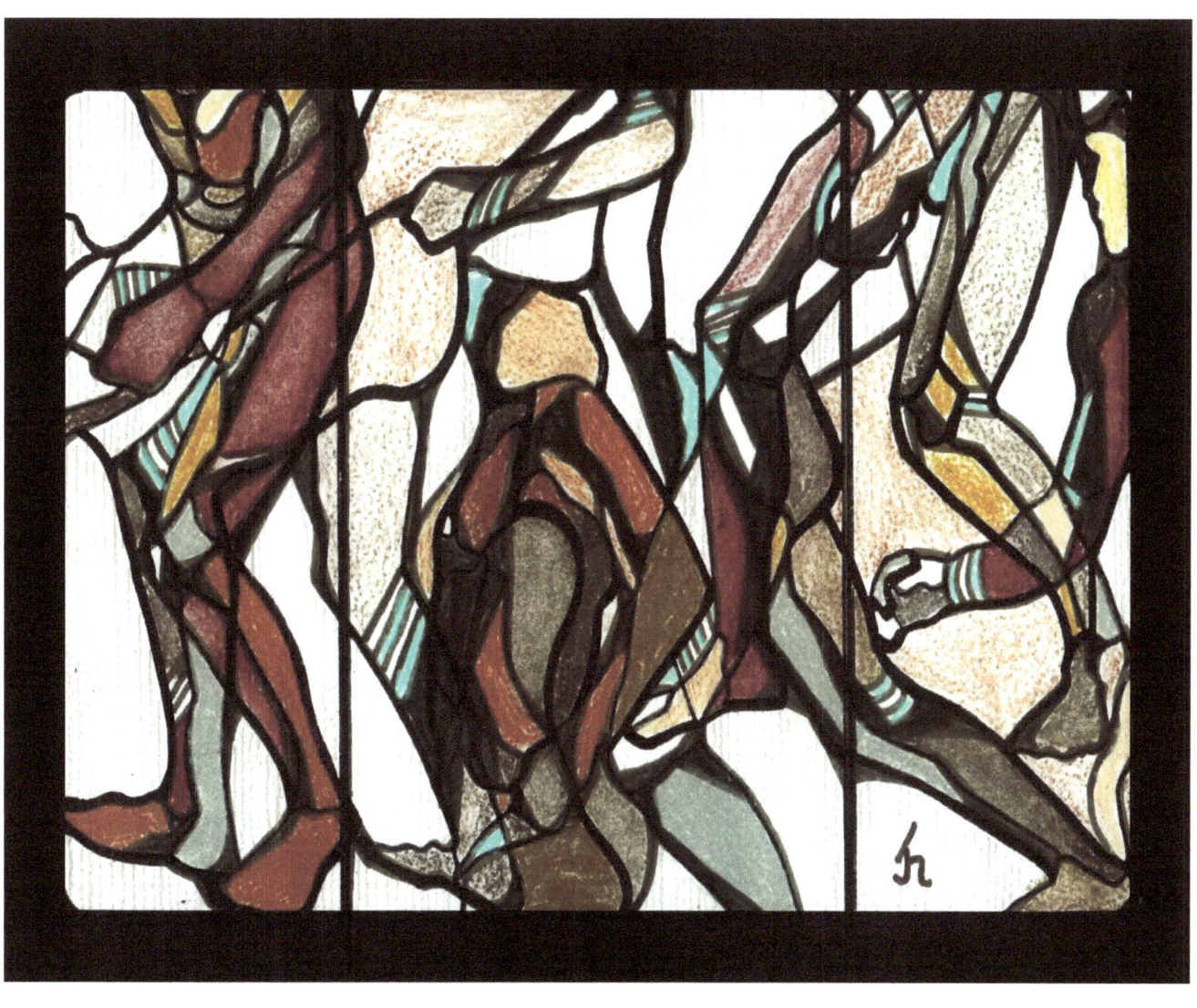

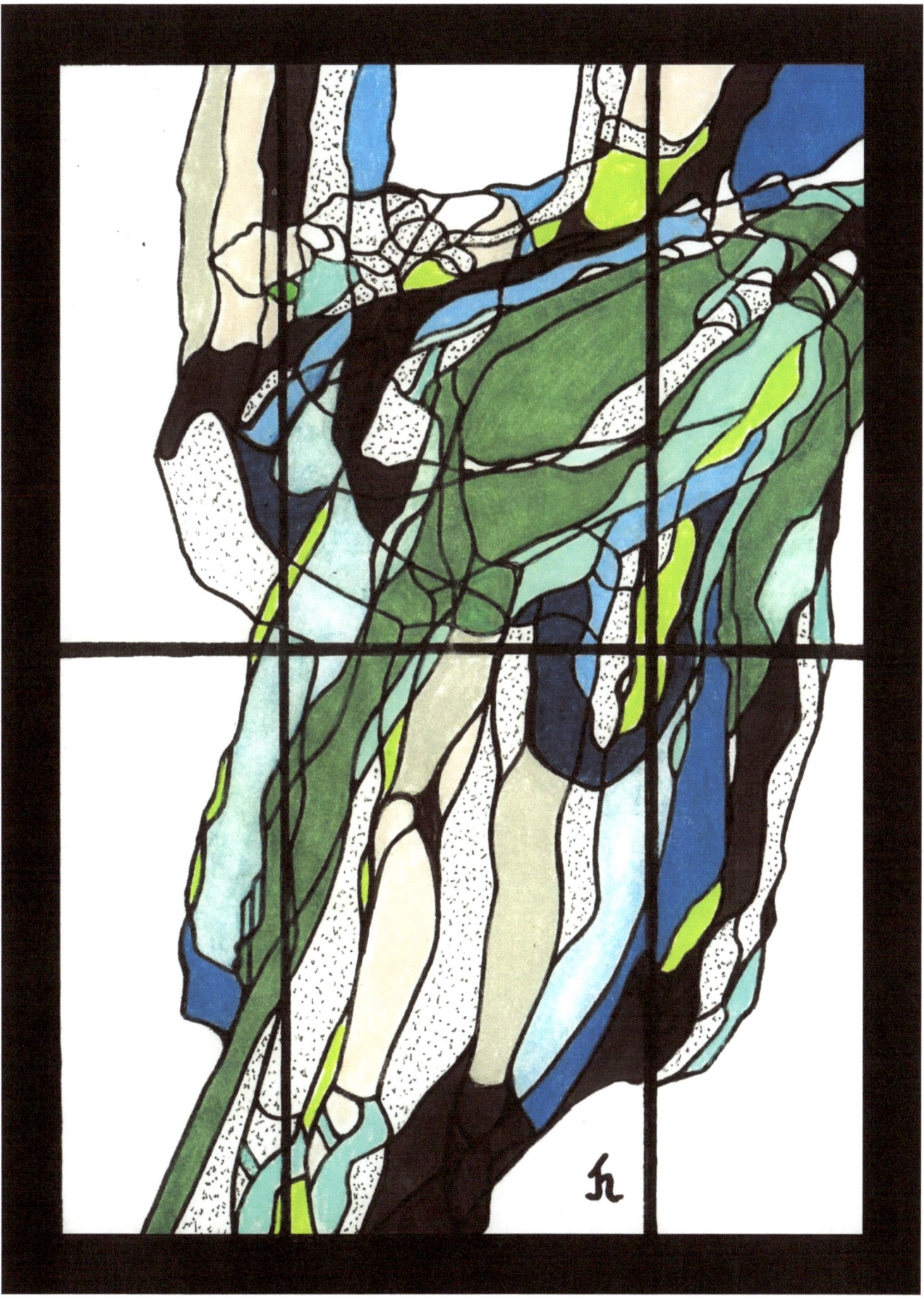

**Accept the upward
sweep to fly
with noble friends,
bringing joy forever.**

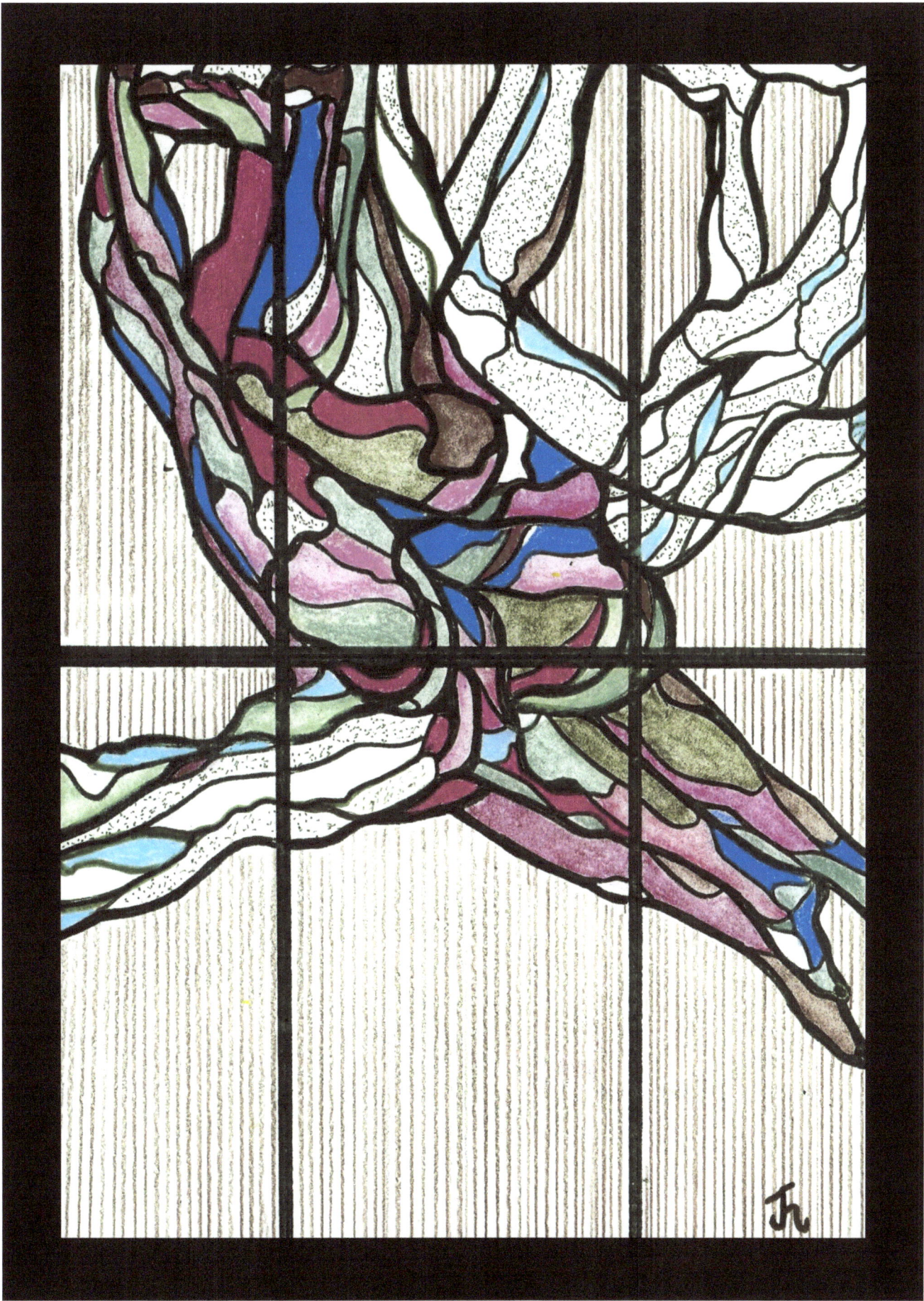

www.ingramcontent.com/pod-product-compliance
Lightning Source LLC
Chambersburg PA
CBHW050739180526
45159CB00003B/1286